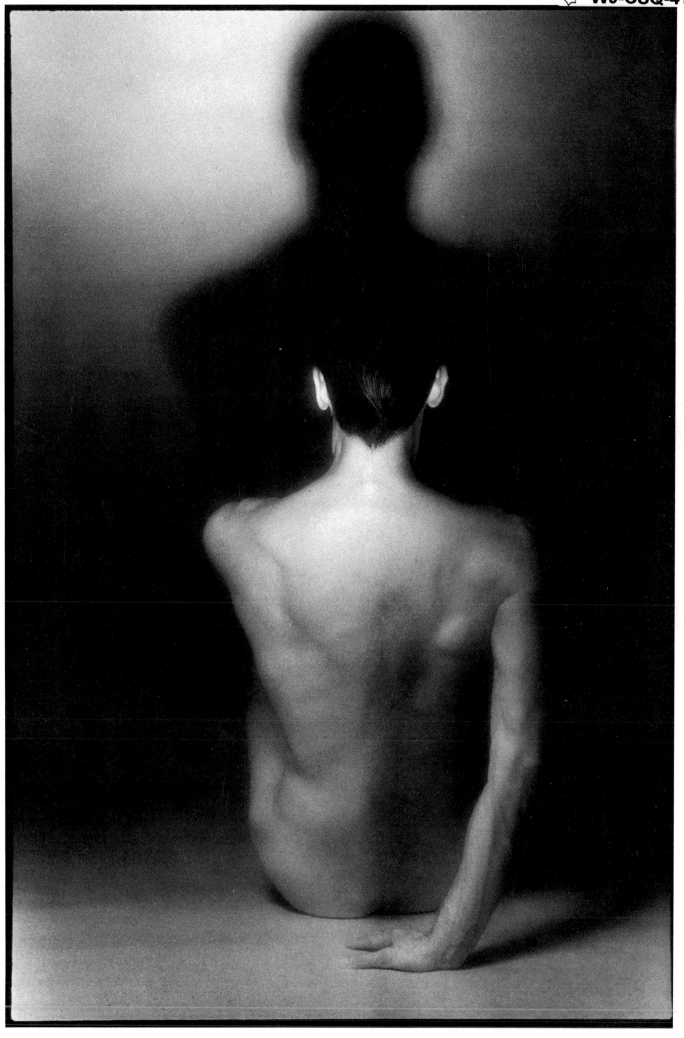

FARBER
NUDES

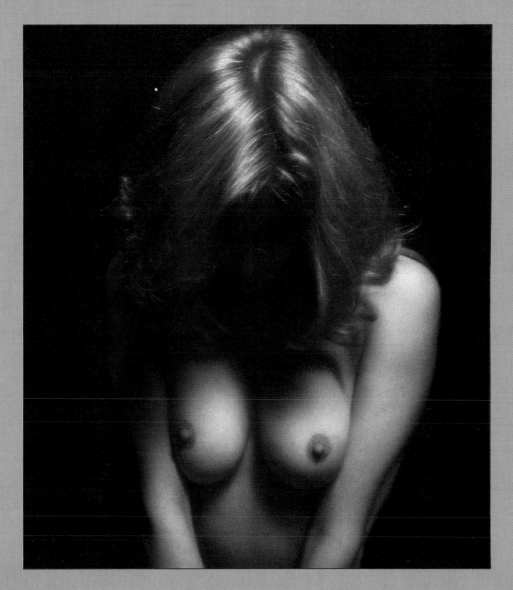

BY ROBERT FARBER

 COLUMBUS
BOOKS

For my wife, Judith, and our child, Devon Nicholas

Copyright © 1983 by Robert Farber

First published 1983 in New York by Amphoto, American Photographic Book Publishing,
an imprint of Watson-Guptill Publications, a division of Billboard Publications, Inc.,
1515 Broadway, New York, N.Y. 10036

Published in the United Kingdom by Columbus Books,
Devonshire House, 29 Elmfield Road, Bromley, Kent, BR1 1LT
ISBN 0 86287 033 X

Library of Congress Cataloging in Publication Data

Farber, Robert.
Farber nudes.

1. Photography of the nude. I. Title.
TR675.F366 1983 778.9'24 83-15106
ISBN 0-8174-3851-3

Manufactured in the United States of America

2 3 4 5 6 7 8 9/87 86 85 84 83

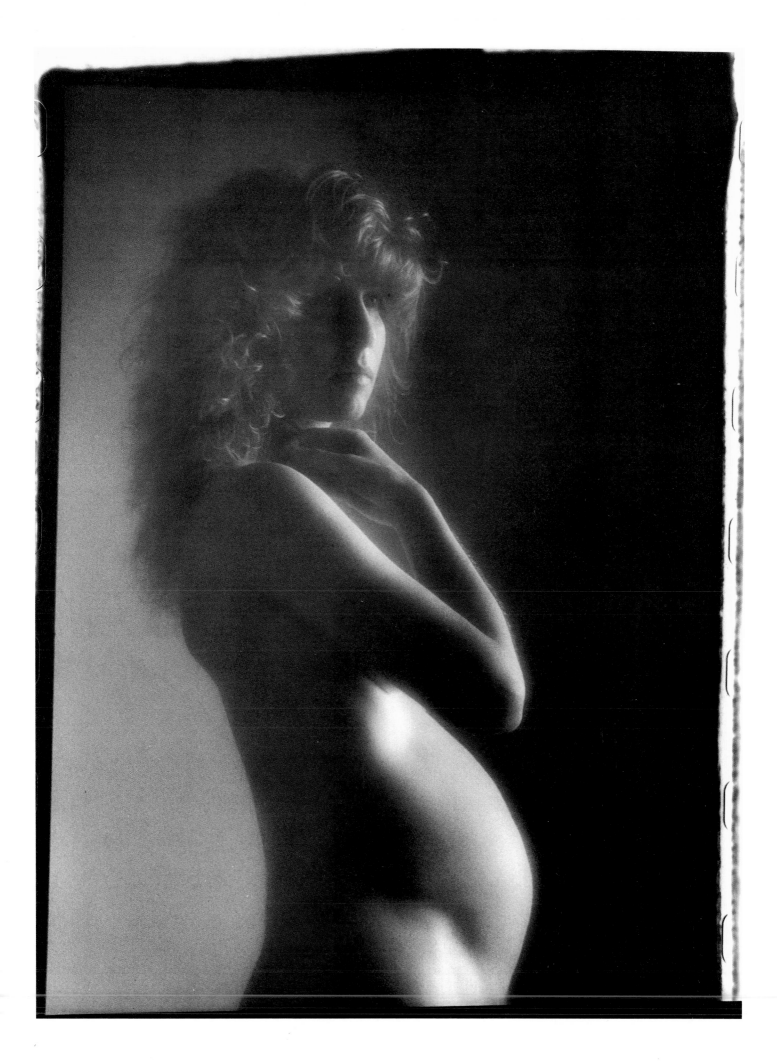

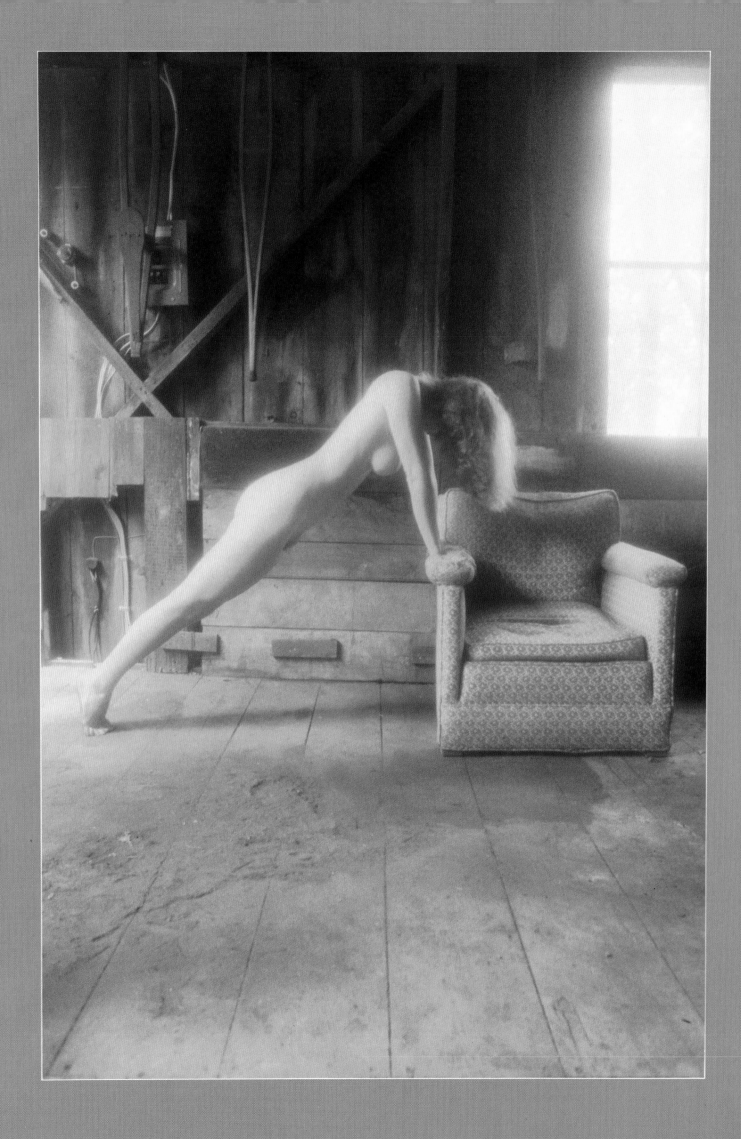

CONTENTS

Introduction

Farber Nudes has been a revelation for me—different from any other collection of photographs I've done. It's a real departure from my work in fashion and advertising, which requires a different set of limits than I feel when I'm working to please my eye alone. The make-up artist, the designer, and manufacturer have an invisible presence in fashion and advertising photography, and creating a successful commercial picture means having to satisfy all of them as well as myself. It's an exciting and challenging business, but with different rewards than I have received from creating the book you hold in your hands.

In Farber Nudes I could pare down the picture-taking process to three elements: the camera, the model, and myself. If the book meant more freedom for me, it was a freedom to let my mood and the mood of the model—and whatever setting we happened to be in—be the only guides I had. It was an exhilarating feeling—sometimes a bit frightening.

I did use mostly fashion models in this book, but the models were free to be themselves in a way they can't be in commercial work. It wasn't always easy to get them to relax. Fashion models are used to being directed—not unlike most actors—and the nakedness of not only their bodies, but also of the situation (just me and the camera), made more than one of my models self-conscious at first, in ways they'd never be doing an ad for make-up or clothes. It wasn't the nudity that led to self-consciousness—most models are justifiably proud of their bodies—but the lack of direction. Where was the make-up man? What are we advertising? What am I supposed to *do*?

Working on this book was an "unlayering" process that had to do with much more than the shedding of clothes. There was nothing I or my models *had* to do—no designer dress or gleaming sportscar to set off to best advantage—and as we realized this, we began to relax and begin a process of discovery. Alone on a beach, in the quiet of a carefully lit and shadowed studio, in the woods, wherever we happened to be, the models in these photographs allowed their bodies to express an amazing, spontaneous range of emotion. Women used to rigid fashion poses, or to having to "perform" on command, slowly discovered hidden playful, sad, pensive, even comic selves. Something essential in each of these people was gradually unleashed—a sense of joy. What I've tried to capture in this collection is a dual sense of discovery—mine and that of the models.

Bodies are fully as expressive as faces. Sometimes the arch of a back, the curve described by an arm, the tension of an outstretched leg can evoke responses that a facial expression can't. Faces are more readily "signatures" than bodies—they can distract from the whole. In many of these photographs, you won't find the eyes, nose, and mouth; I found that the anonymous sweep of a torso, or the delicate series of planes in "disembodied" hips and buttocks often seemed like sculpture that the addition of a face would diminish. When there *are* faces in these pictures, they're included because I feel they add to the whole sense of a body's rhythm or stance.

Why are the majority of these photographs of women? The first explanation is simple: I love how women look, act, and move. I've also had a good deal of experience photographing women, both nude and clothed, and I'm continually fascinated by how the female form "adapts" to its surroundings. A number of pictures here—a woman lying on rock, standing amid trees, or even posed by the exact lines of a white piano—intrigued me because of the powerful contrast between the fluidity of the female body and whatever "immovable" object was next to it. The soft rhythms of the female form seem to flow against the rock, the trees, the piano—exemplifying a purity and adaptability of line I don't generally find to the same degree in the male form.

However, while I willingly confess to my preference for photographing women, there are a number of men represented here who display two masculine sides that I find intriguing. A man photographed *with* a woman can seem, again, like a strong object around which the female flows. I'm fascinated by the visual "support" a man can give a woman—a little like the function of a male dancer in classical ballet, which is largely to support and lift his partner. You'll see a few pictures in the book in which I've tried to convey this—the secure strength of a man's arm in contrast to the softness of the female body next to it.

The other masculine forms I've included here convey quite a different sense. It is sleek and stylized—a Hollywood-in-the-20s Valentino type—a man who might be a dancer posed quite formally in a carefully lit setting reminiscent of the art deco style. This is a quality I've aimed for with women, too: the pictures of a woman next to a white piano evoke for me a whole, lamentably lost era. There's a wonderful sense of containment to me in these images—the arc of the body in a precisely shadowed setting.

This stylization may seem to be a radical swing of the pendulum away from the natural outdoors and beach scenes—it is meant to be. I don't believe you have to put a human being outdoors to make him or her "beautiful" or even "natural." The wide spectrum I hope I've achieved with these photographs has as much to do with variety of setting as with the variety of the models' physical stances. In fact, setting is inseparable from the model it encompasses. Some of these pictures were taken in the studio under "artificial" conditions—carefully controlled light and shadow, as in the art deco representations; some were taken under a continually changing sky outdoors, the natural light waning and waxing and dictating almost more than I could what the final result would be. The effects of these radically different settings add, I hope, to an exciting and diverse whole: a spectrum of the ways in which human beings can be beautiful.

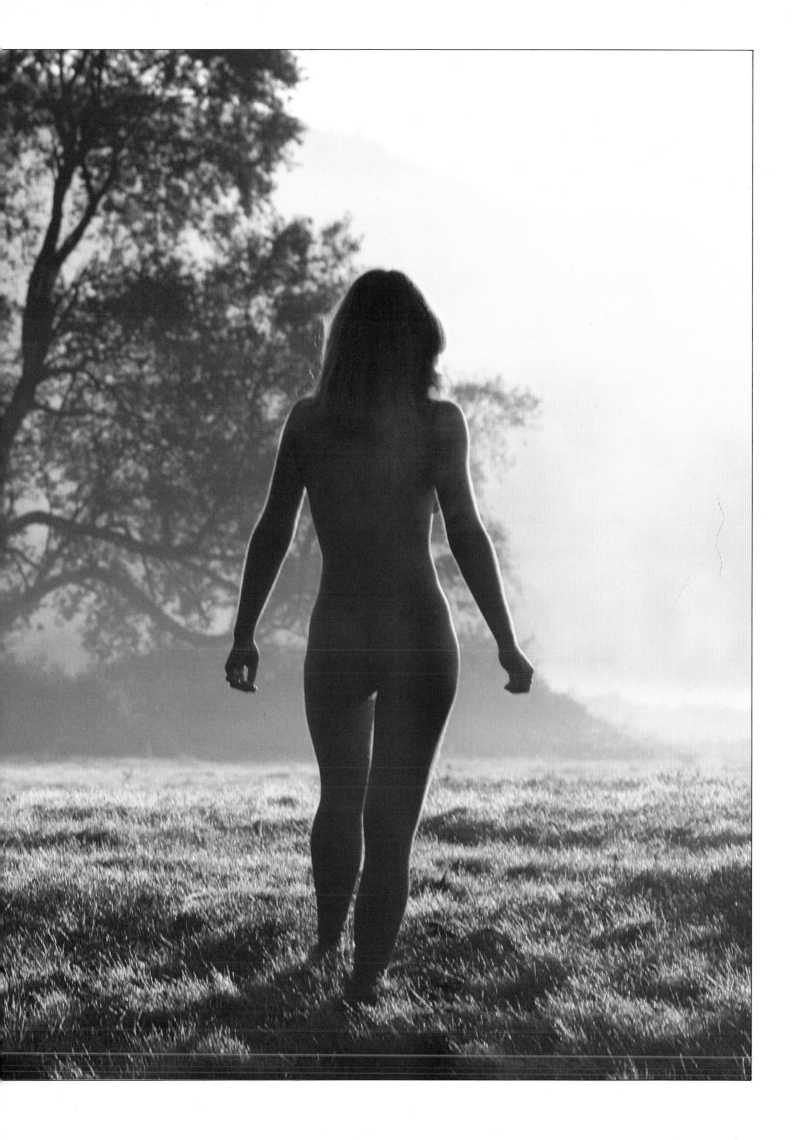

Avoiding monotony in mood was a major aim in this book, but I've also tried to avoid monotony in "sculptural" form. If I can make any generalization about these photographs at all, it's that in each I've tried to capture a sense of wholeness. In the same way that faces can be distracting in a full-body photograph, so can certain parts of the body. There were times when I felt the need to de-emphasize breasts, thighs, or buttocks. There's always an erotic temptation to focus on a particularly appealing "part," but that kind of objectification just isn't compatible with the sense of the human form I'm after in these pictures. The line between the erotic and the pornographic has to do with just this: pornography is disembodied from any sense of a whole human being; the erotic allows that wholeness to exist. If some or many of these pictures are erotic, it's an unashamed eroticism—something I'm happy spontaneously occurs.

Another kind of wholeness I was after has to do with graphics: the interaction of line and form. One of the most exciting things about photography is how it can draw, paint, or sculpt. I had the leisure in these pictures to *play* with their elements. There were times when the body seemed to me a gentle, rolling landscape; there were times when an arm and hip seemed to create a stark abstraction—the whiteness of the form against a dark background. Photography to me seems best when it plays with illusion—creating something far more than a bald representation of an object. Not all photographs need to appear as three-dimensional "sculpture": there are times when the delicate flatness of an etching can transform the subject. I've tried to capture both senses here.

Yet another wholeness I was after has to do with color, or the lack of it. You'll find both color and black-and-white pictures in the book, and whether I chose one or the other had more to do with intuition than anything planned. Color can be dangerous—it can be another distraction. My work has been described as "painterly," and it is true that I'm influenced by a wide variety of painting styles, particularly the Impressionists. But what I seek in color photography is harmony, the easy interaction of model and background. This is especially important to me in nude photography—the gentle gradations of tone in the naked human body seem to me to cry out for equal gentleness in a color surrounding. I strive more for sharp contrast in black-and-white, although of course a black-and-white photograph can deliver the same world of light-to-dark as one in color. But for me, black-and-white photography isn't quite as potentially volatile as color: color is a tool to be used with gentleness and alertness.

I've said before that this collection is completely different from my previous ones—and it is. But that's not to say that commercial photography is completely removed from "art" photography. In fact, I don't particularly like the concept of "art" photography, at least if taken to mean shooting in some Ivory Tower away from so-called "crass commercialism." The enormous amount of commercial photography I've done feeds directly into the work in this book, and vice versa. While the sets of limitations may be different in fashion or advertising from what they were for me in this book, much of the same technique and discipline flows from one to the other.

Shedding commercial limits did, however, loosen me in one way I haven't mentioned. Nothing about this book was preplanned, as everything (or nearly everything) *is* in commercial photography. For instance, I didn't (as a model agency might) inspect these women for "flaws," or in any way make them feel they had to pass a test to model nude. As comfortable as models often learn to be about their beauty, even these physically disciplined women would whisper to me with a grimace that maybe their thighs weren't in quite the best shape, or I might find their hips a little too wide, etc. I'd like to think I quickly disabused them of having to worry about "imperfections"; while I wasn't out to photograph "flaws," it was a whole, *human* sense of the body that I did seek. As my models saw that that was my aim, it became their aim to relax and forget about showing me their "best" sides. Even in the most stylized of these pictures, I felt a sense of inner ease with the models, which may mainly have had to do with the absence of a make-up artist powdering, pushing, and pulling. The bottom line for the models and myself is that we had fun.

More than fun, we felt we made some exciting discoveries doing *Farber Nudes*. I hope you'll feel the same sense of discovery while looking through it.

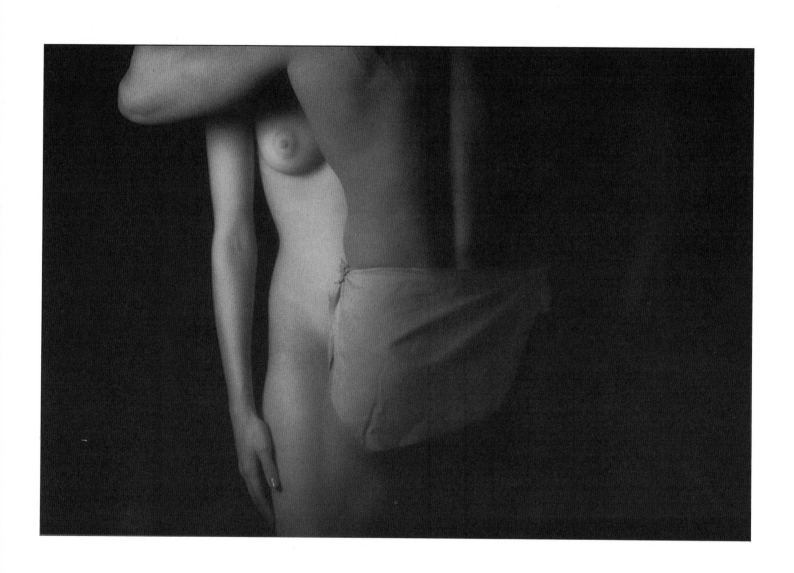

Advice to a Beginner

The first and most obvious problem for the photographer who's never done nude photography is how to find models willing to pose unclothed. In this book, of course, I was able to use models with whom I'd worked in fashion and beauty advertising; I'd established a professional relationship with these people, which allowed a relatively easy transition to photographing them nude. What I'd advise you to do if you don't have access to people you've photographed before is to investigate the art departments of any local college or art school, most of which offer "life classes" that use nude models. You'll often find that simply offering the model prints of the photographs you take can be payment enough—they have portfolios too, and are generally more than pleased to accept contributions to them for which *they* don't have to pay.

The other obvious alternative is to enlist the aid of friends. People with whom you have a close relationship know you're not out to exploit them—and it's likely they'll be flattered that you've asked. There can, of course, be some initial tension even with friends: few people can easily throw their clothes off and pose unself-consciously. What I've done with people—even professional models—who've never posed for nude photography is start with a series of head shots, comfortable soft lighting, and gradually get them to drop a robe. As they get used to being photographed, whatever threat they may feel about the project generally disappears. And again, offering prints of the work you do in exchange will be offering a valued gift.

Detailed technical information about doing nude photography is provided in the final section of this book, but one word of technical advice can be offered here: keep it simple. As far as I'm concerned, loading yourself up with a half dozen lenses is completely unnecessary. I took many of the photographs in this book with only one lens— a Minolta 35-105mm zoom. I have found it's much more important to study and then create your own lighting, so that the subject of the photograph "speaks" more than any fancy camera technique. Studying the use of color and light in such painters as Vermeer, Renoir, and Monet has been more illuminating to me than juggling six lenses and types of cameras to produce an effect. Learning to use a camera and lens to best advantage is exactly like learning to play a musical instrument: you'll find that with practice you can make it work for you—not you for it.

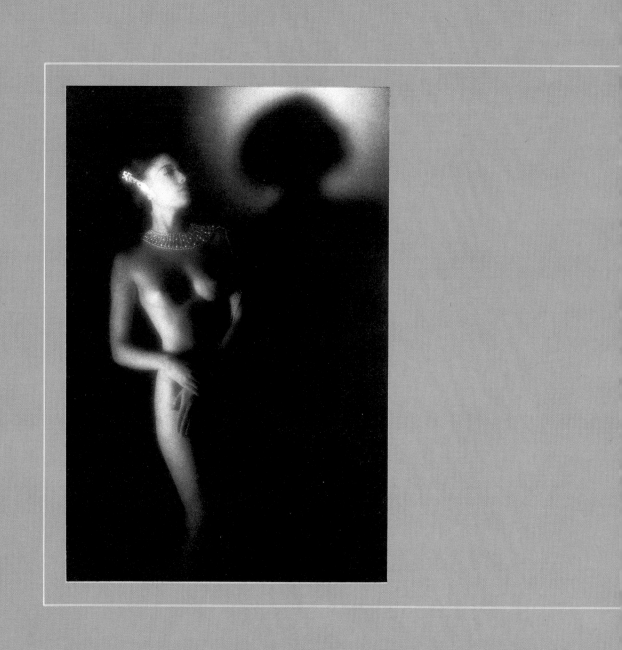

THE
ELEGANT
NUDE

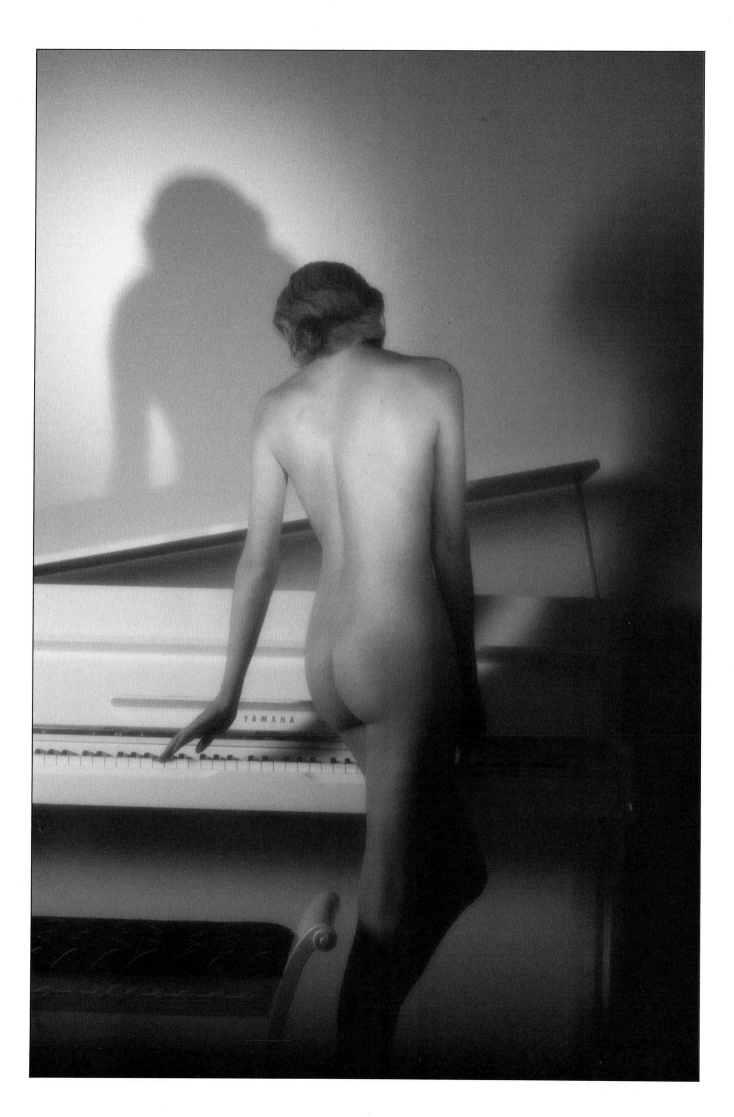

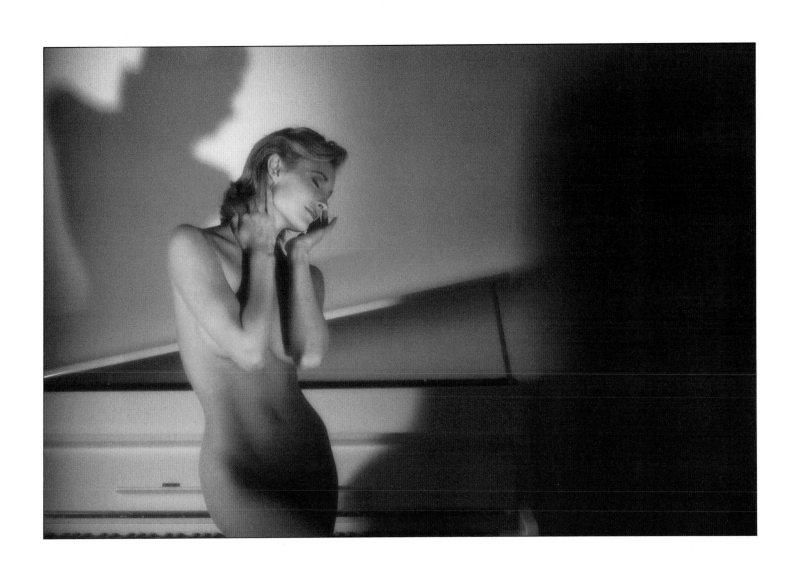

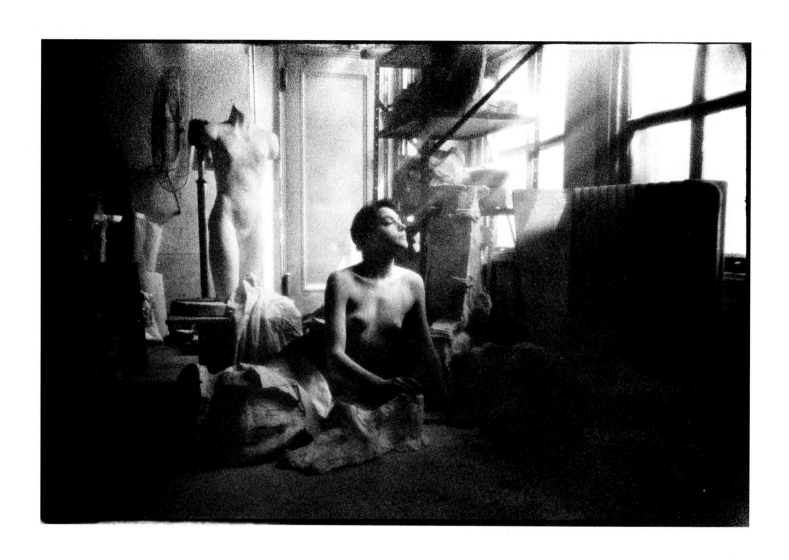

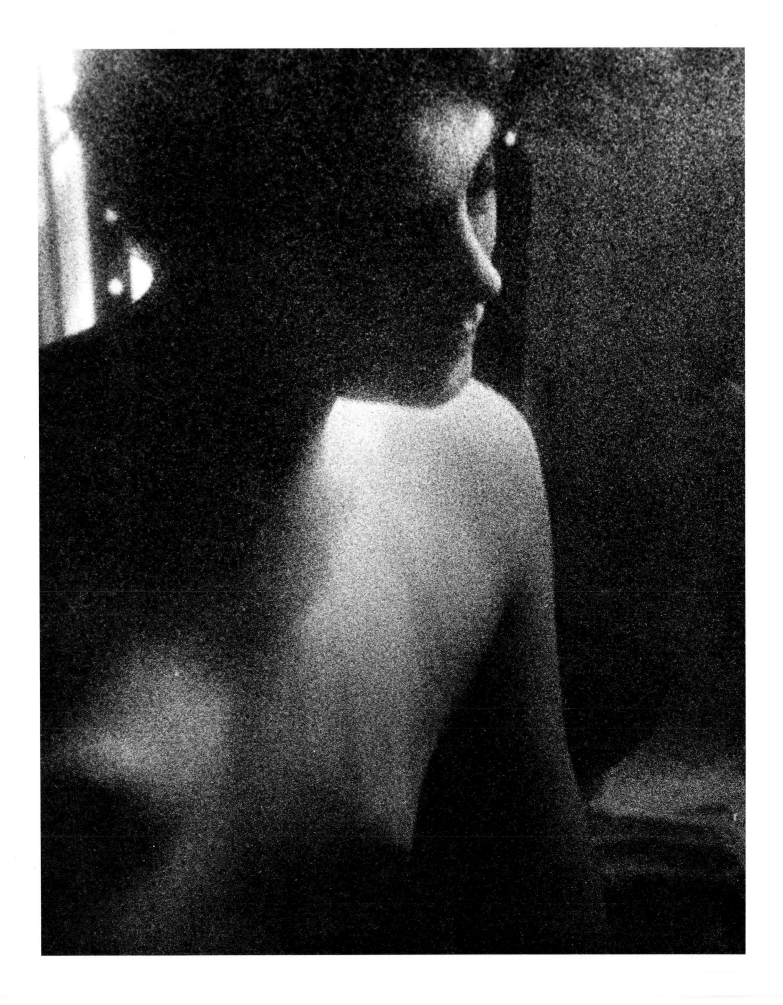

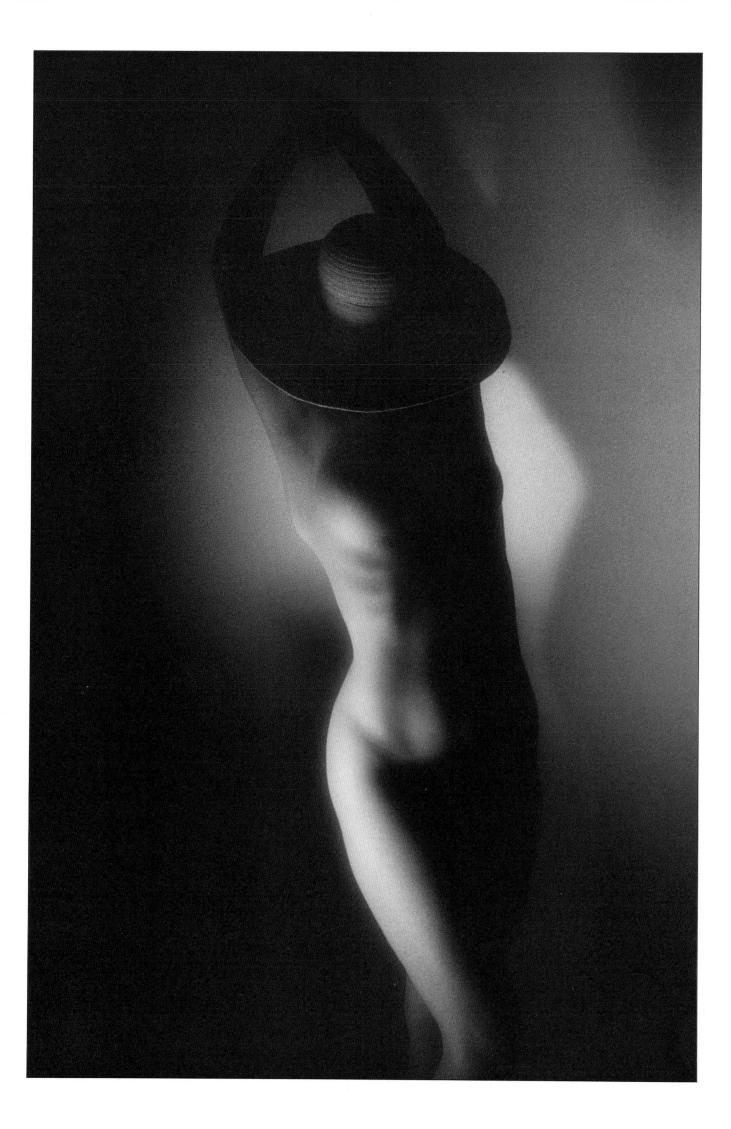

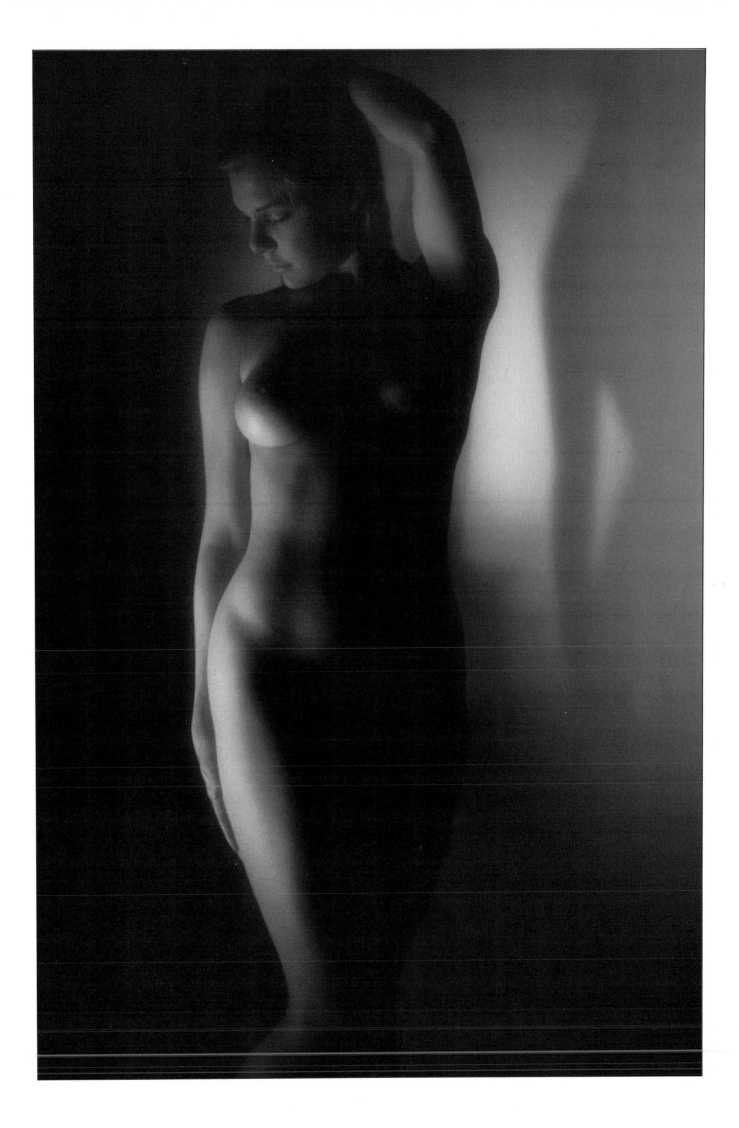

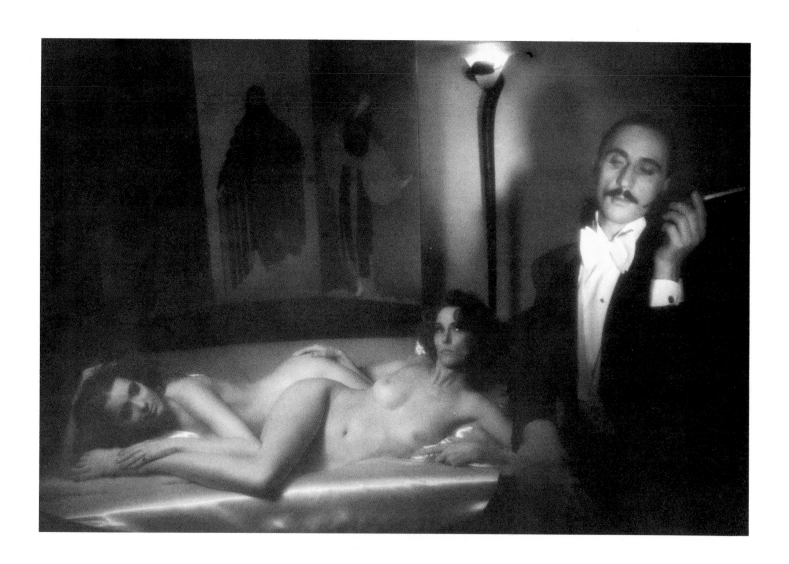

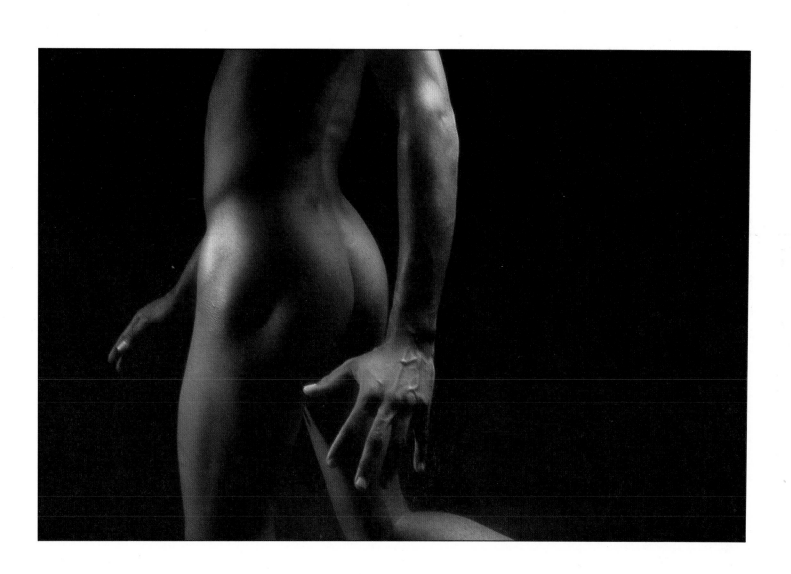

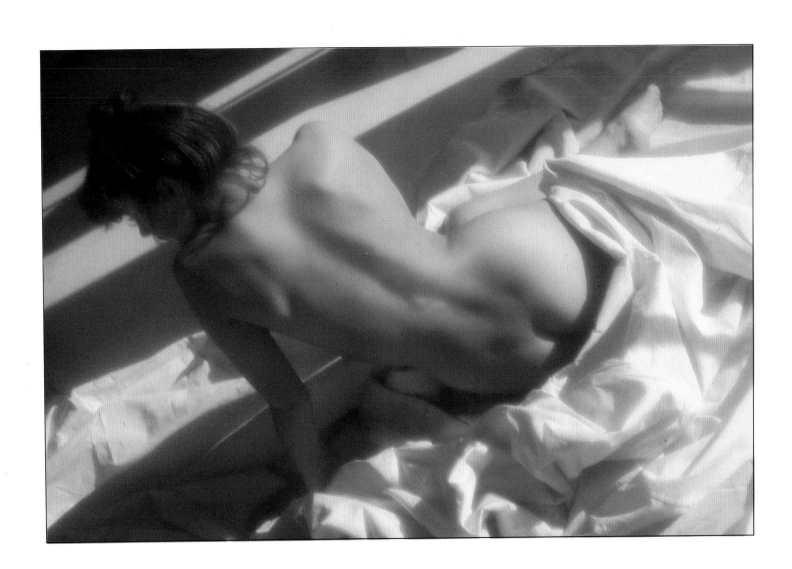

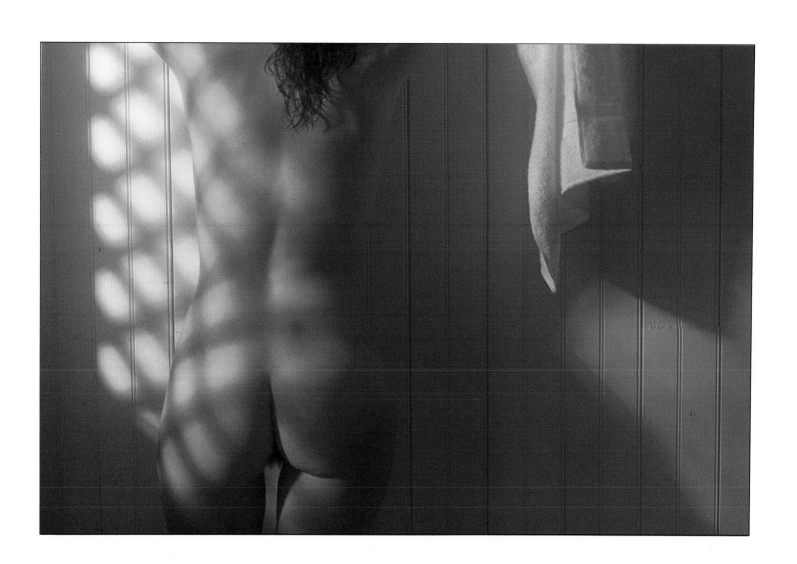

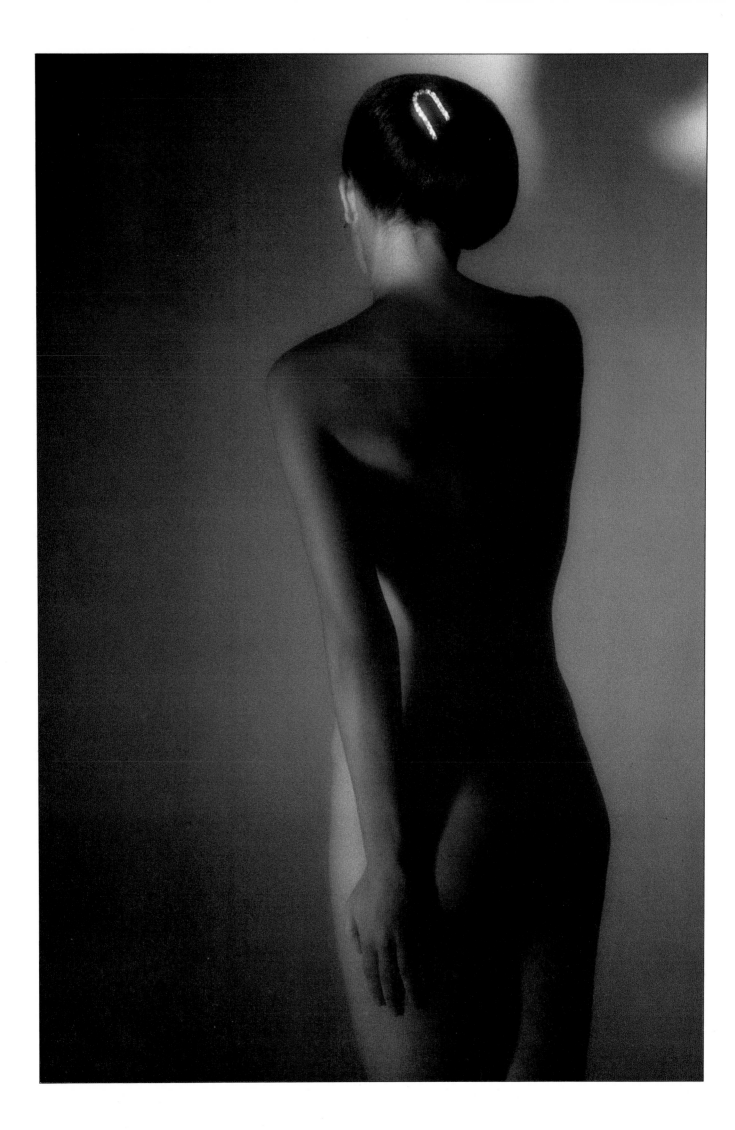

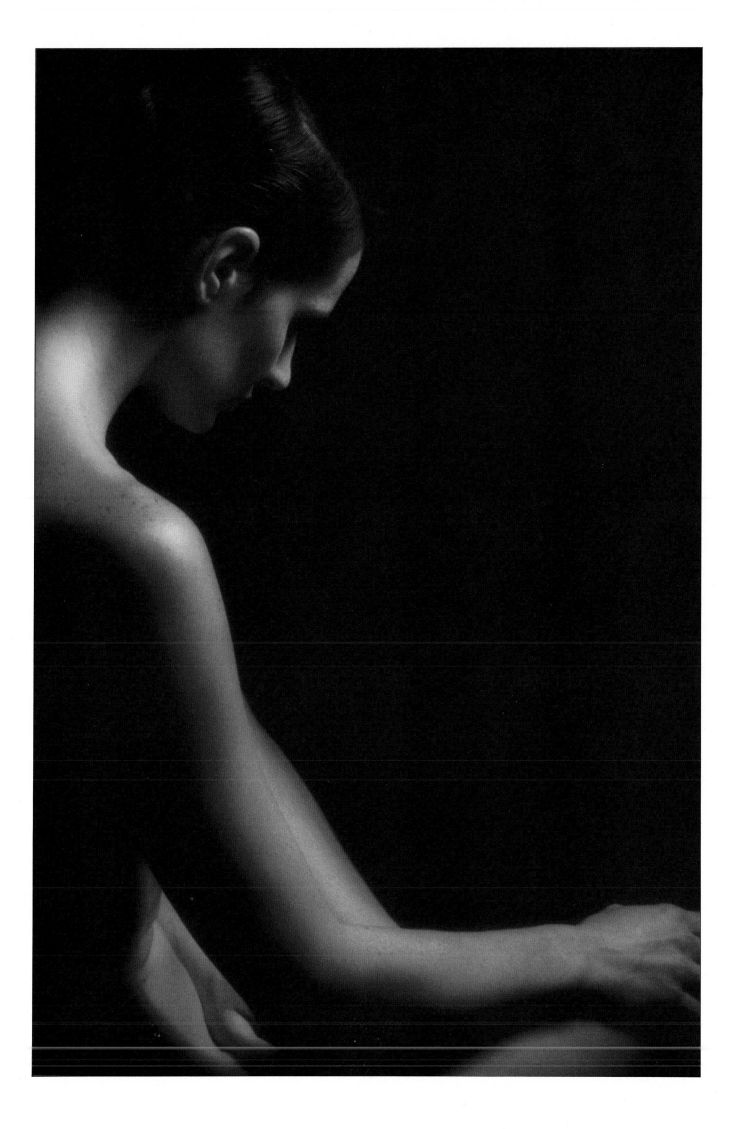

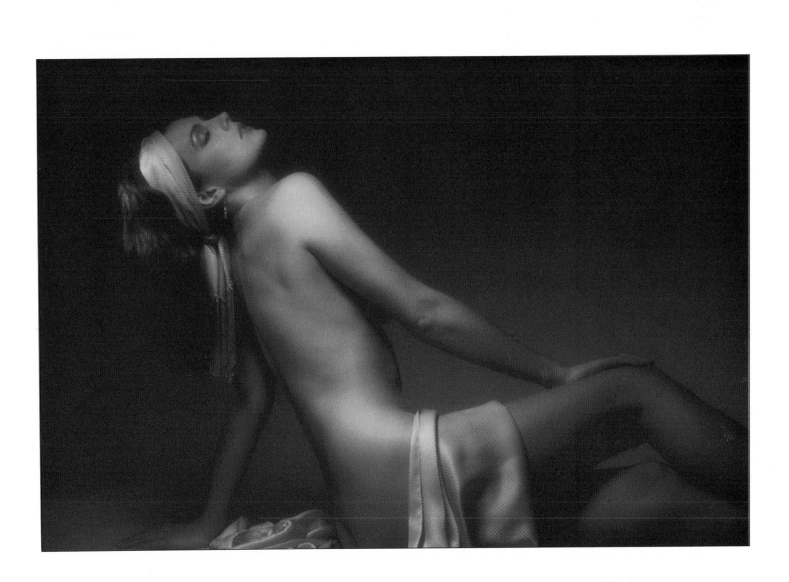

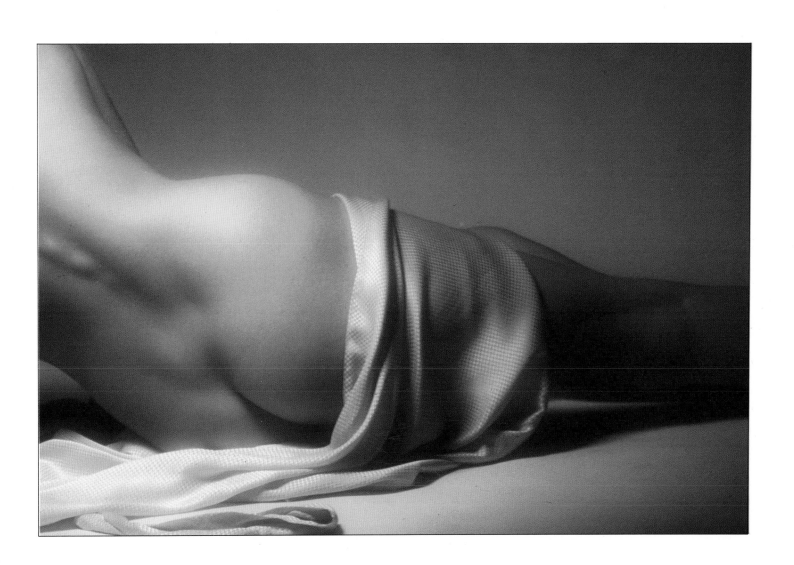

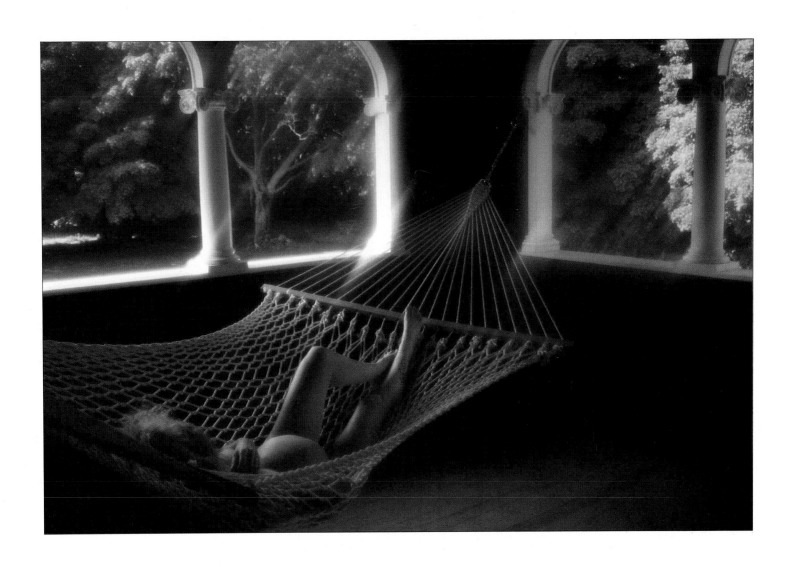

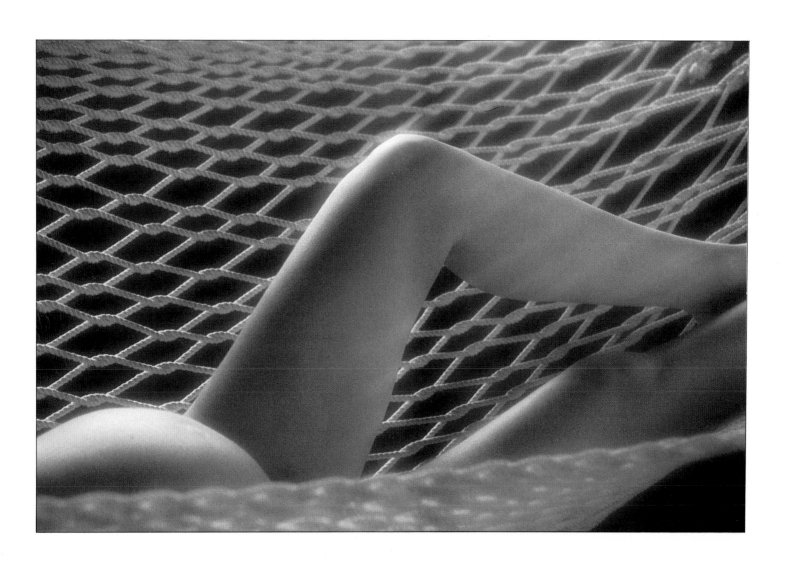

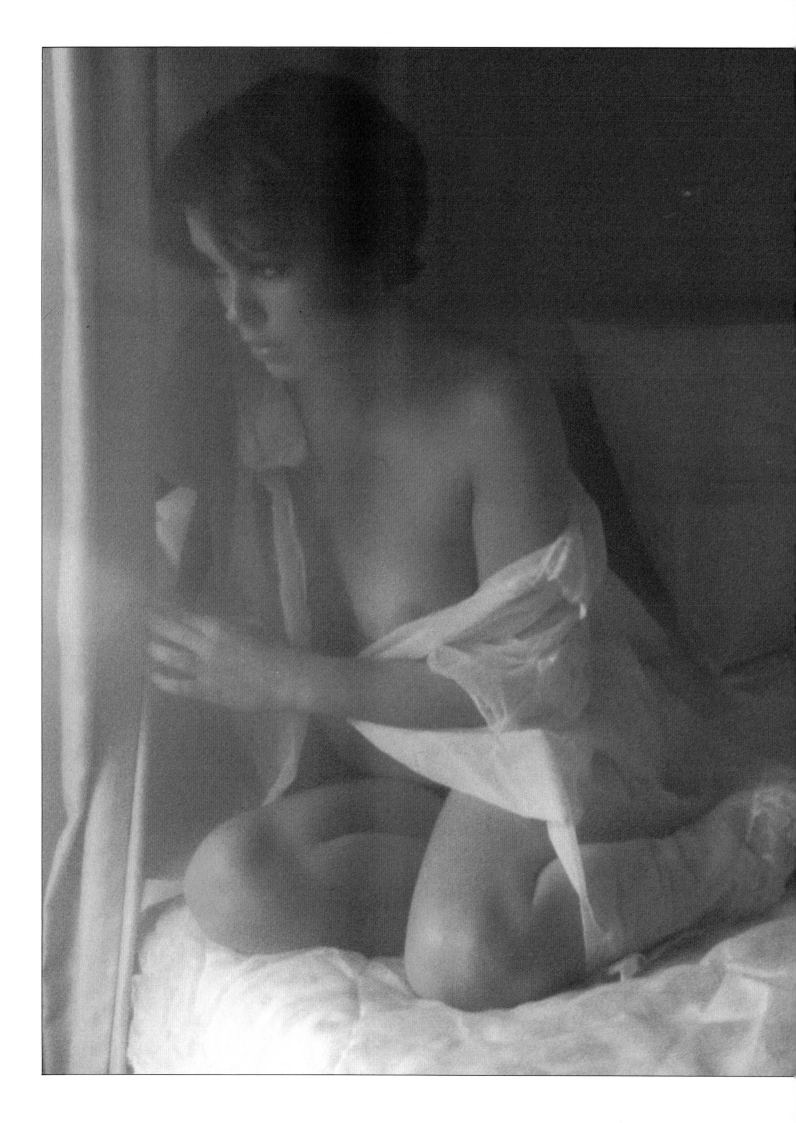

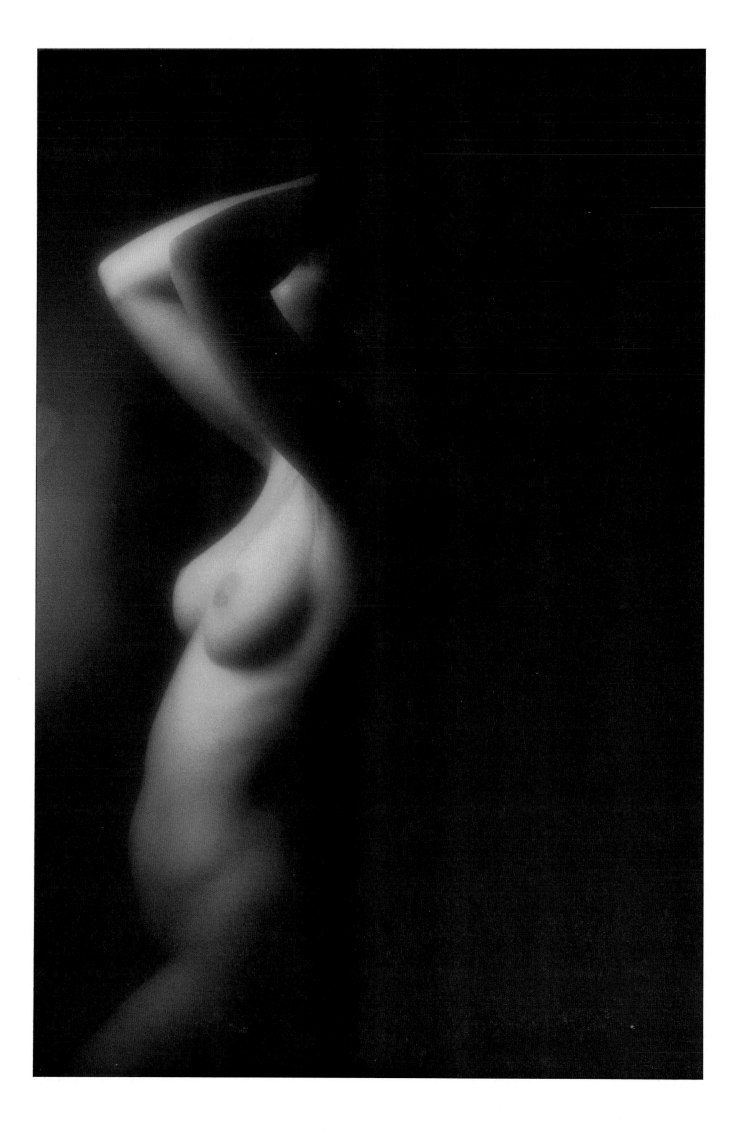

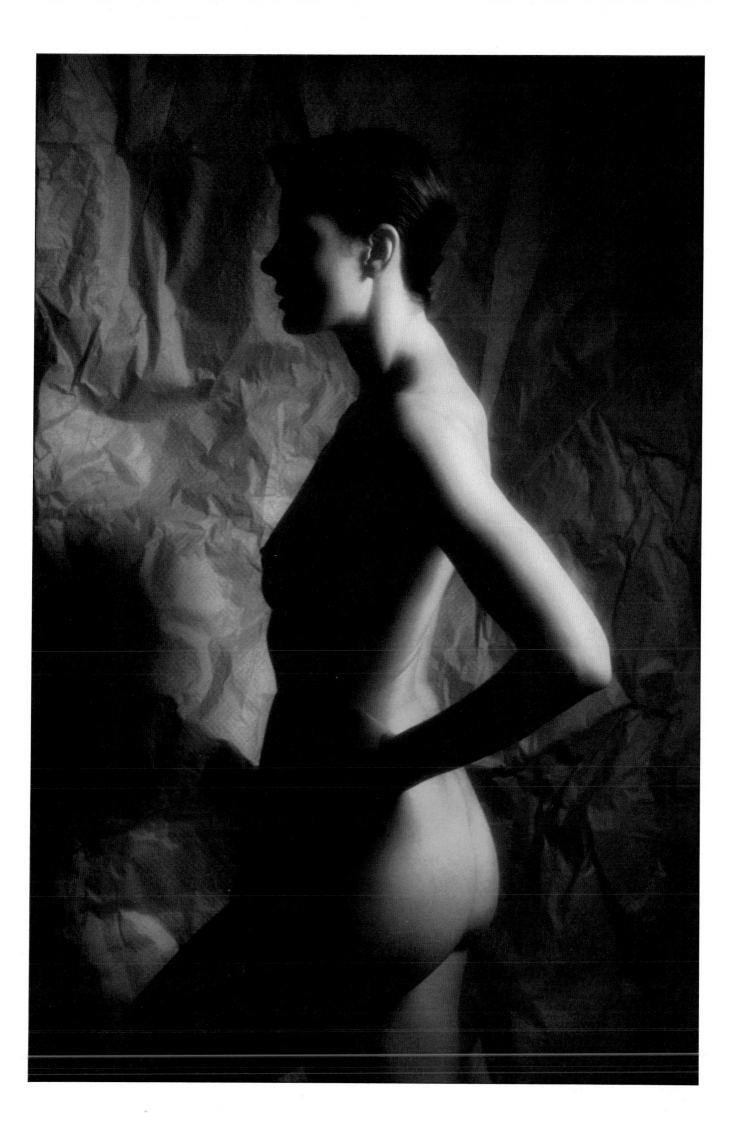

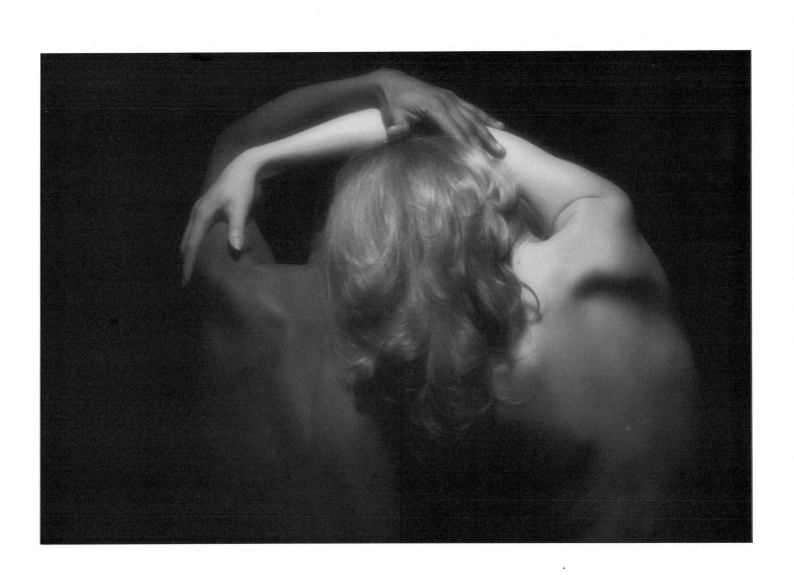

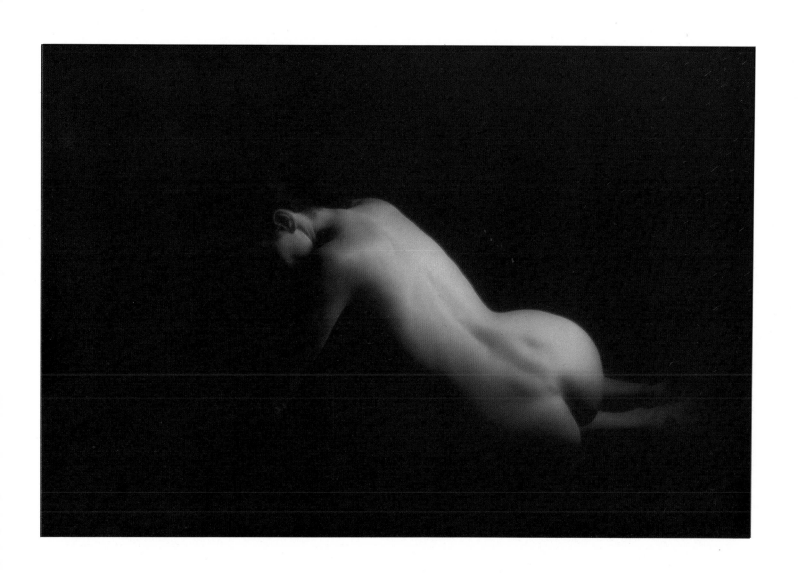

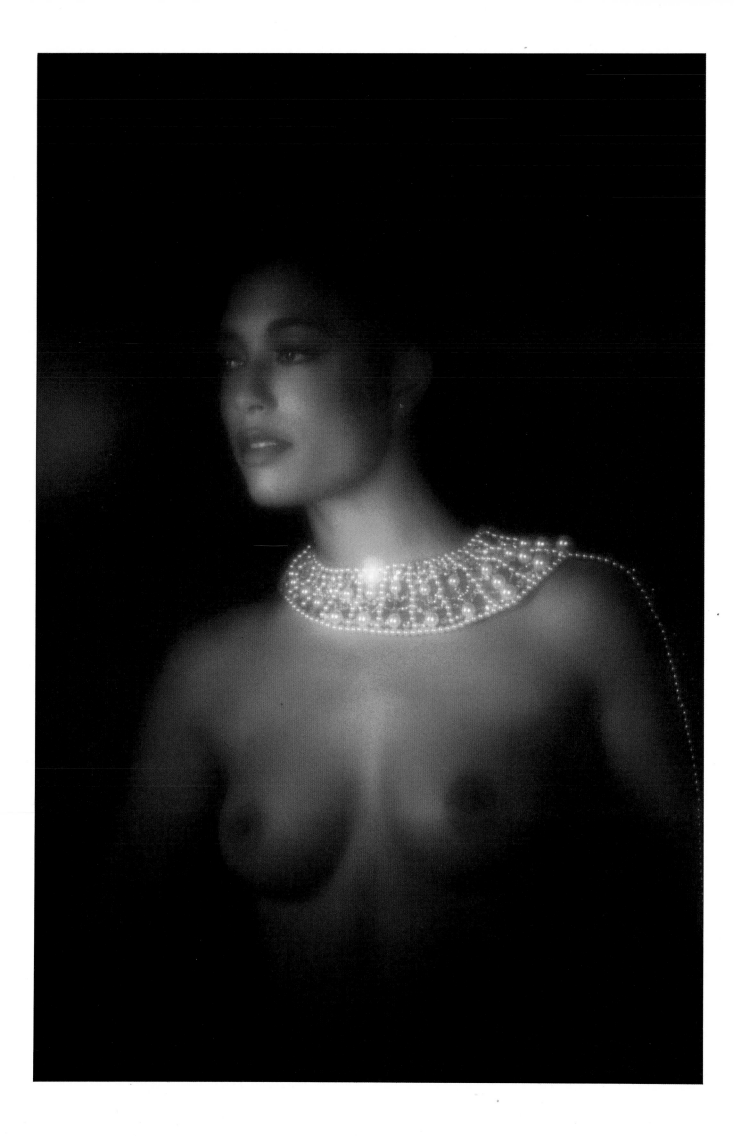

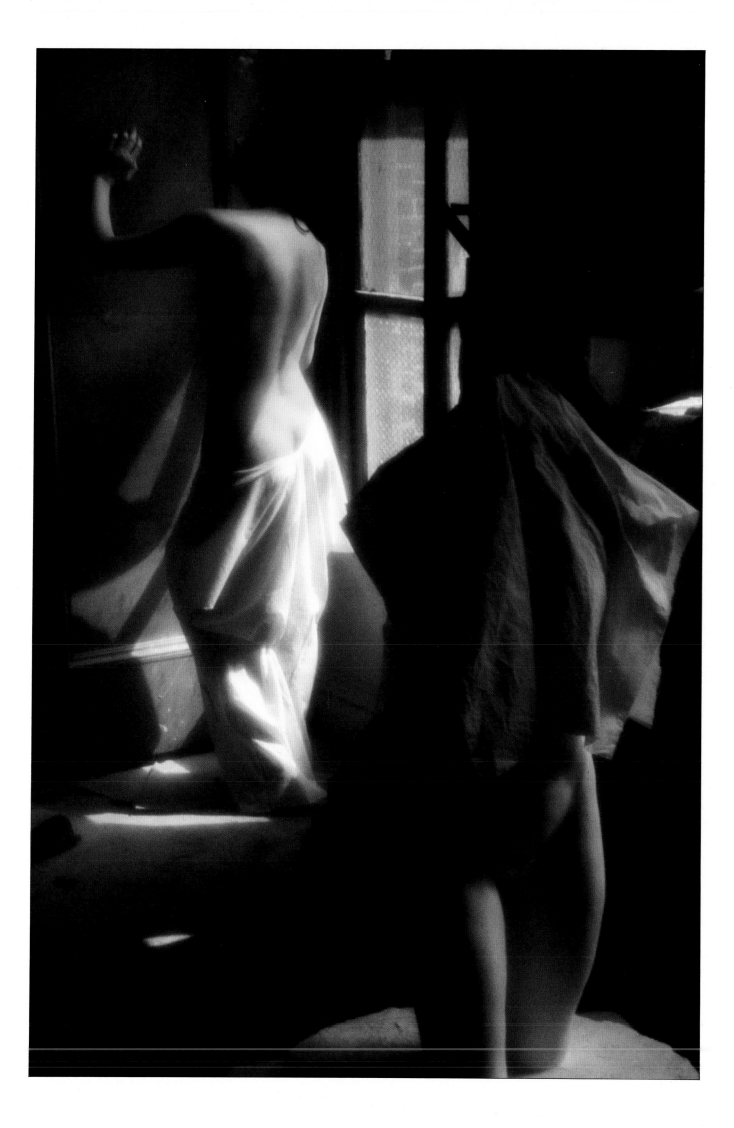

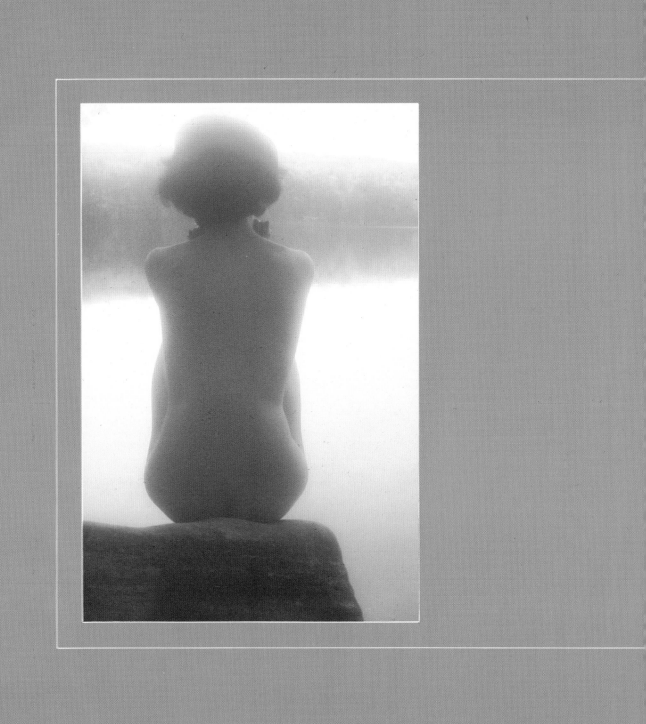

THE
ROMANTIC
NUDE

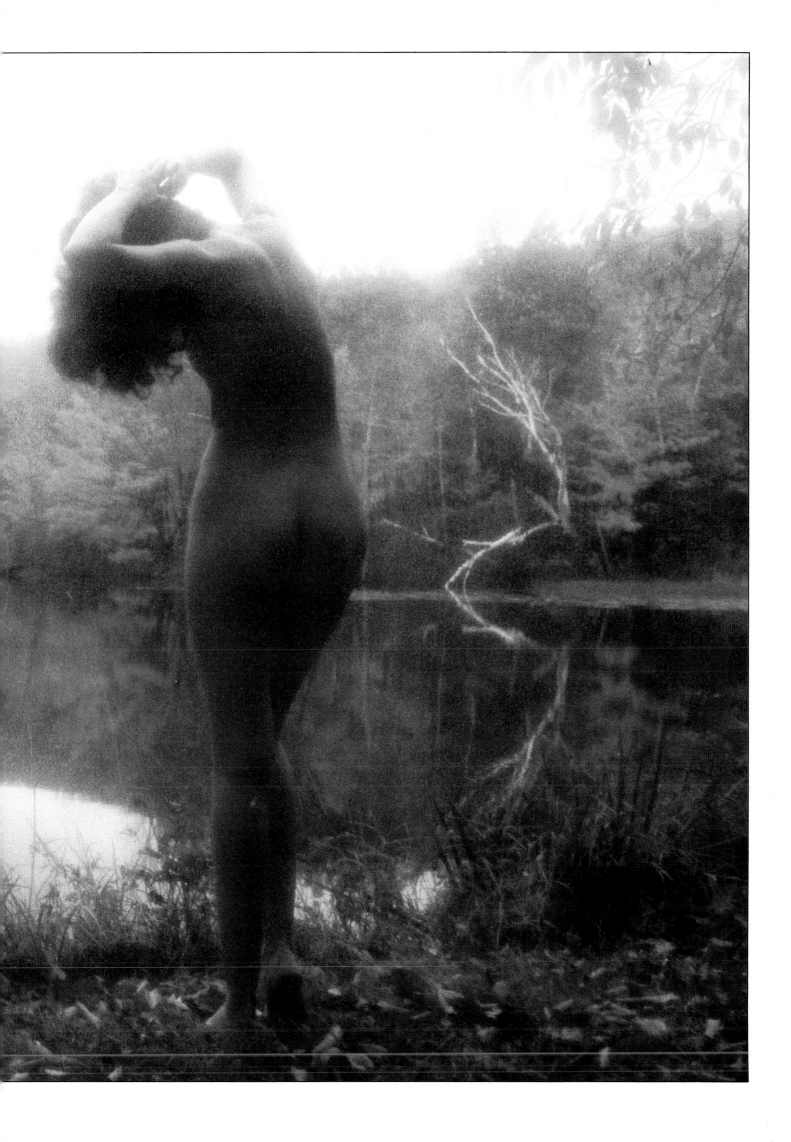

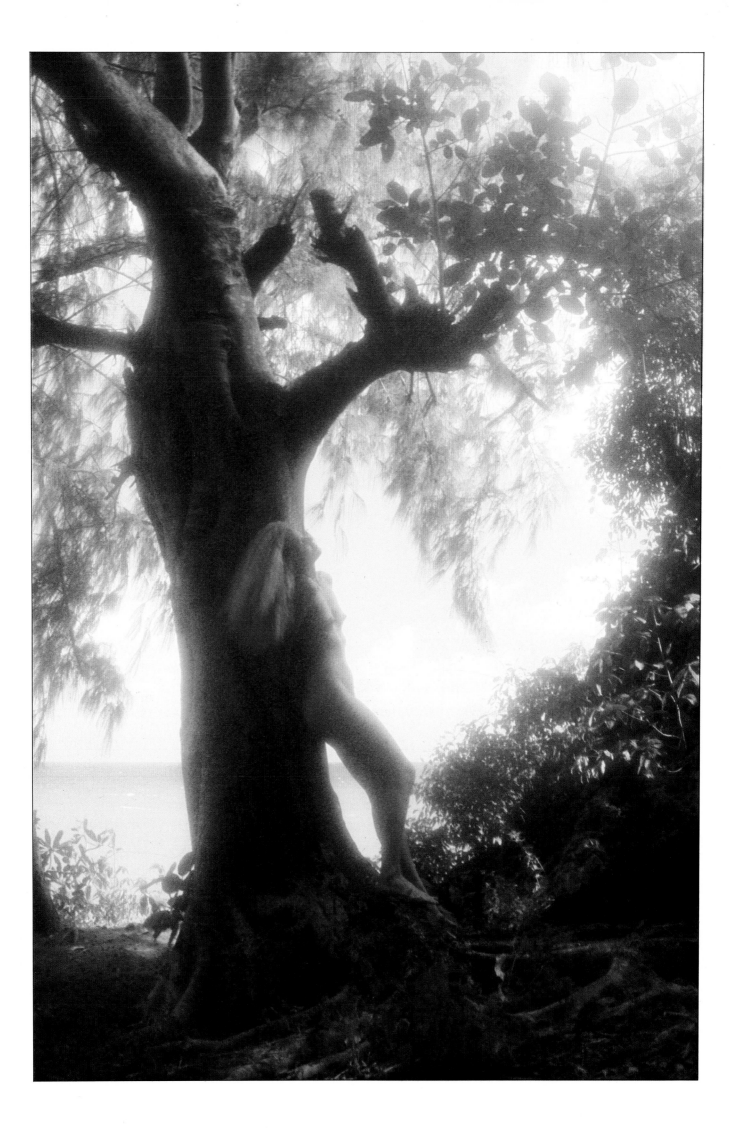

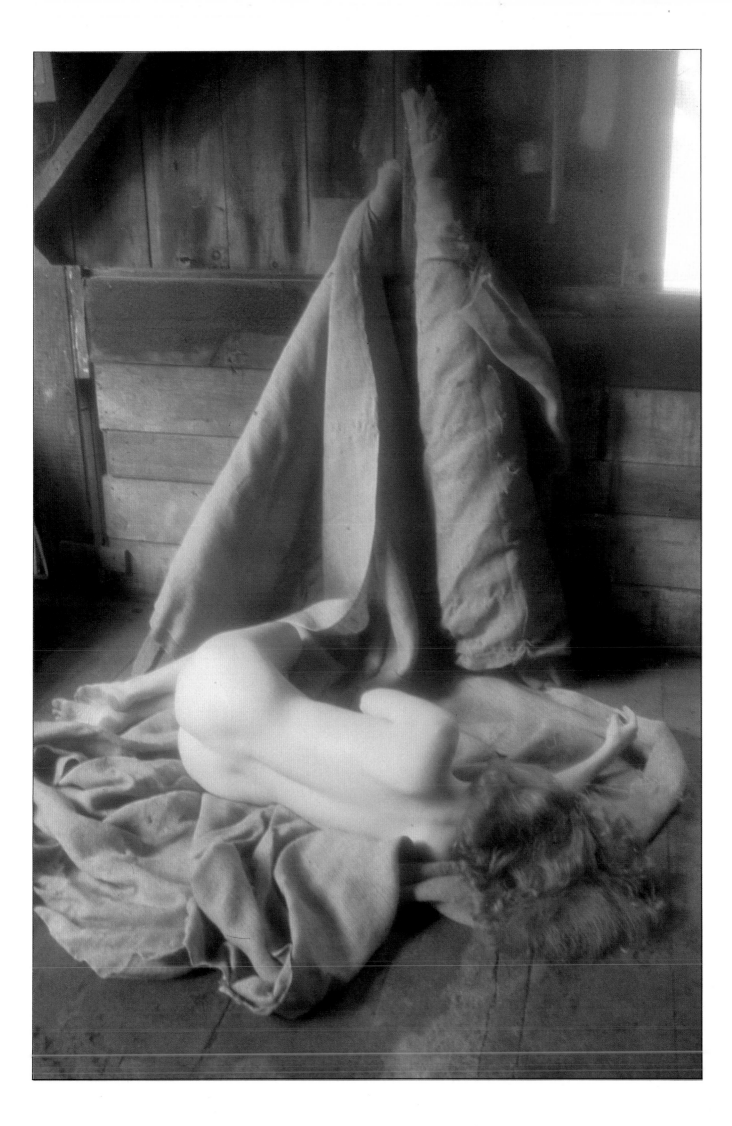

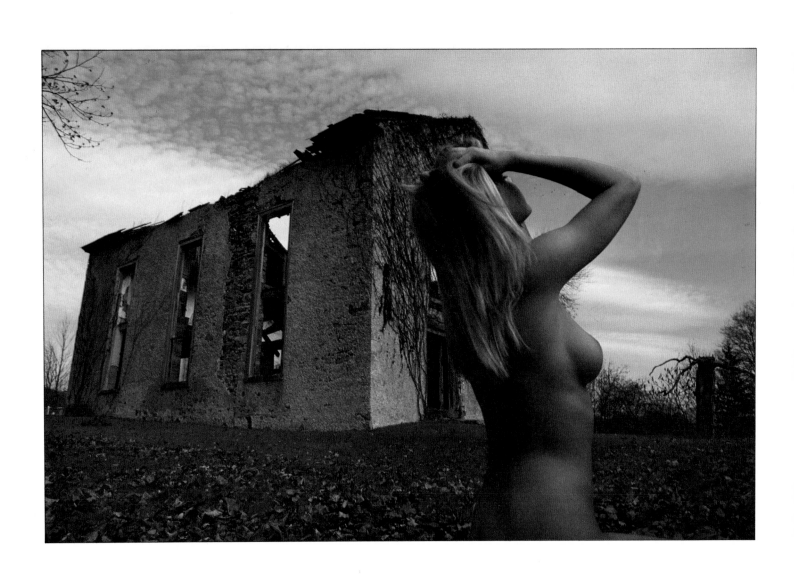

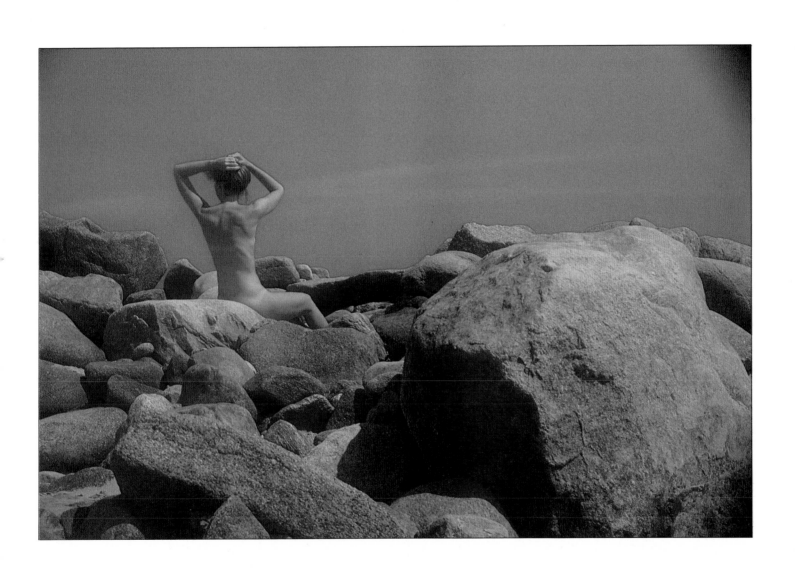

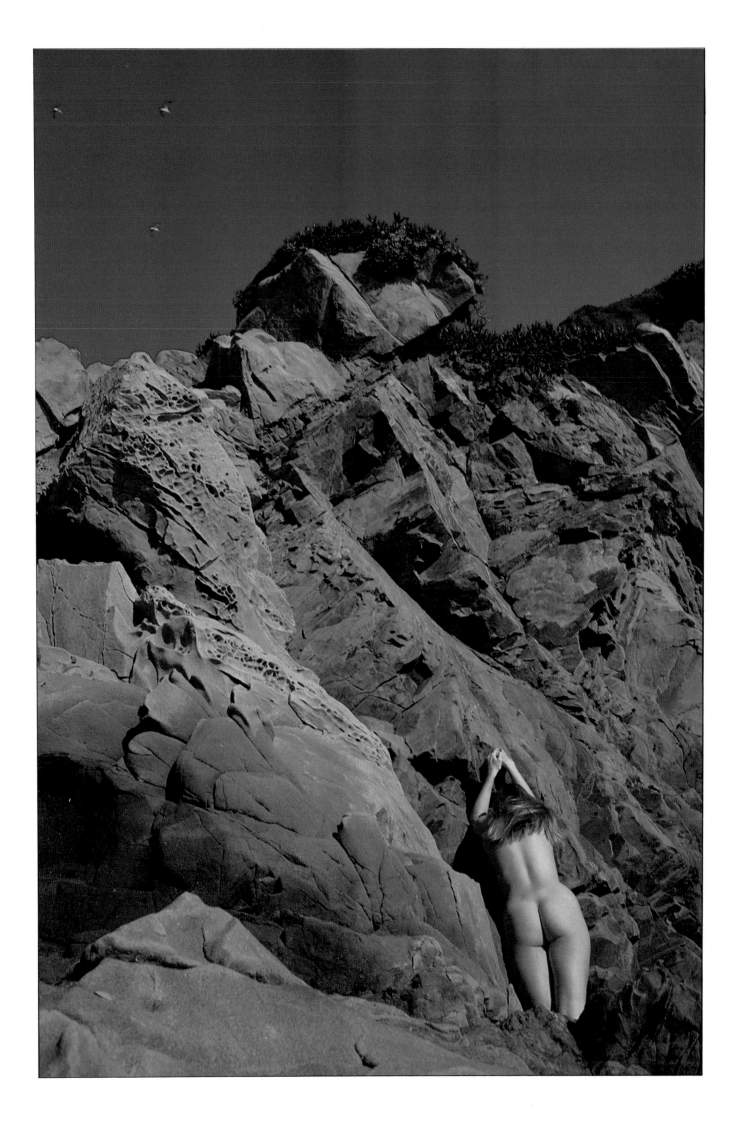

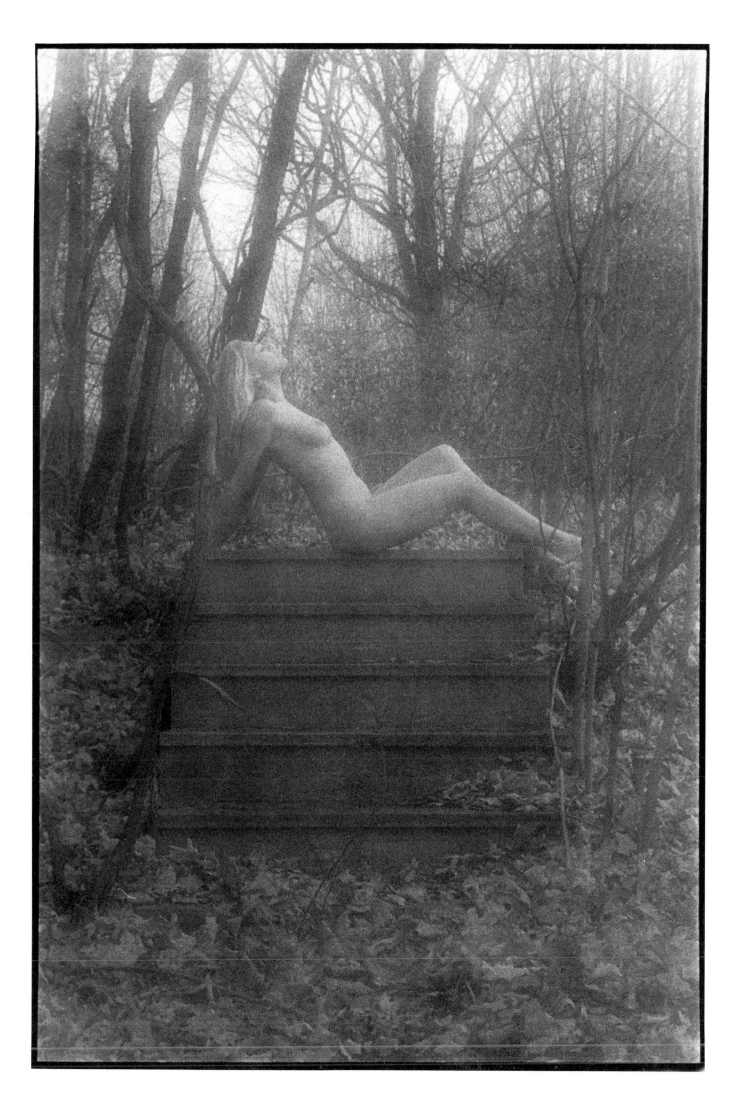

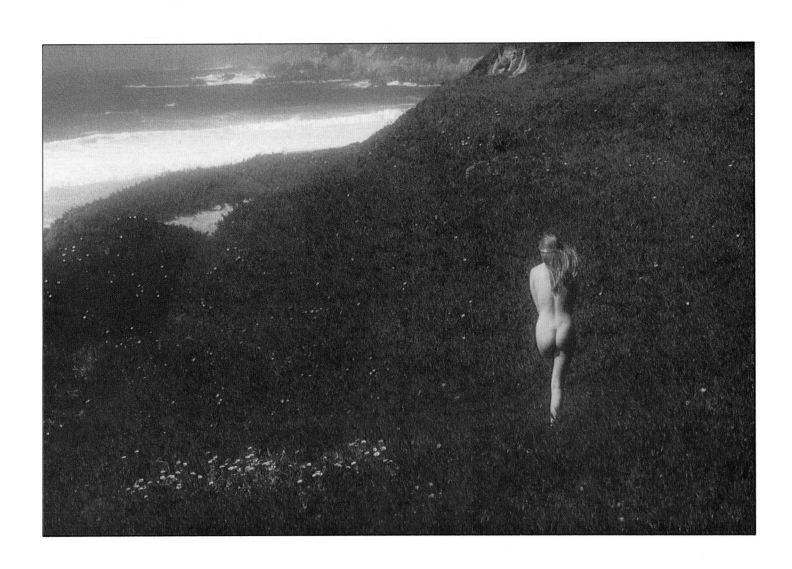

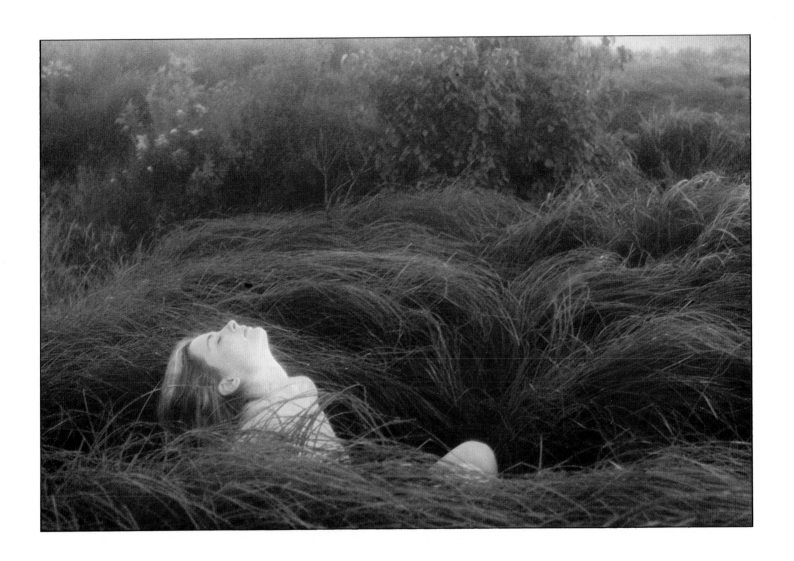

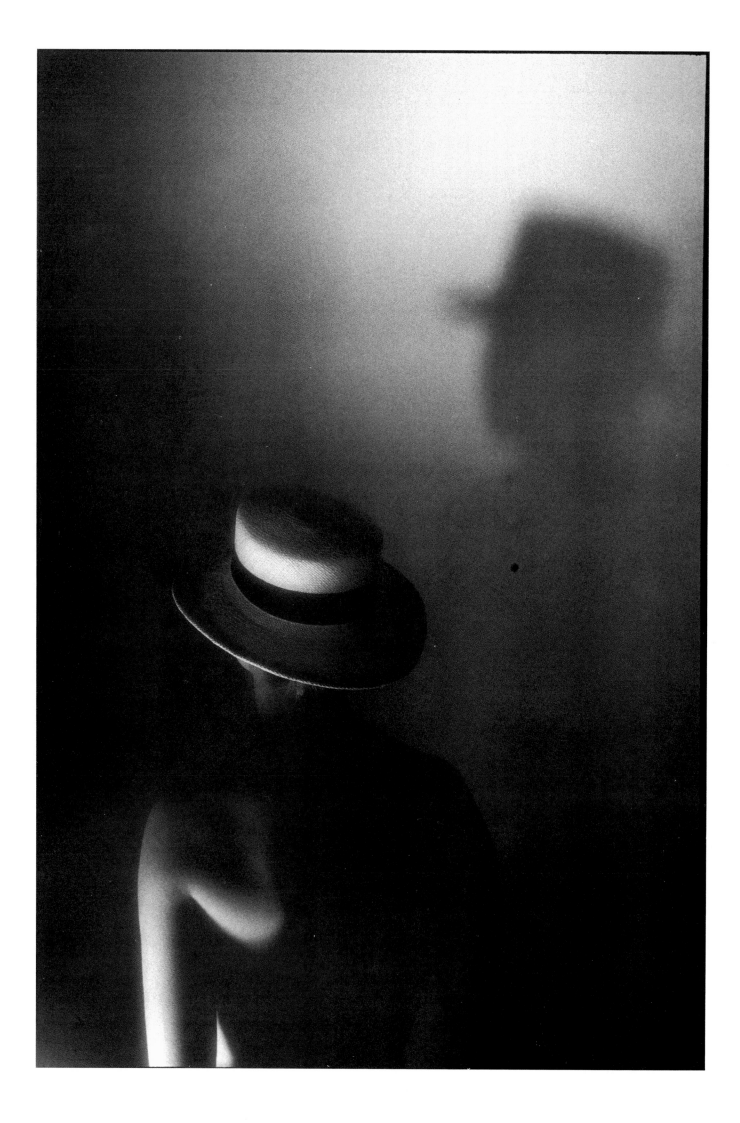

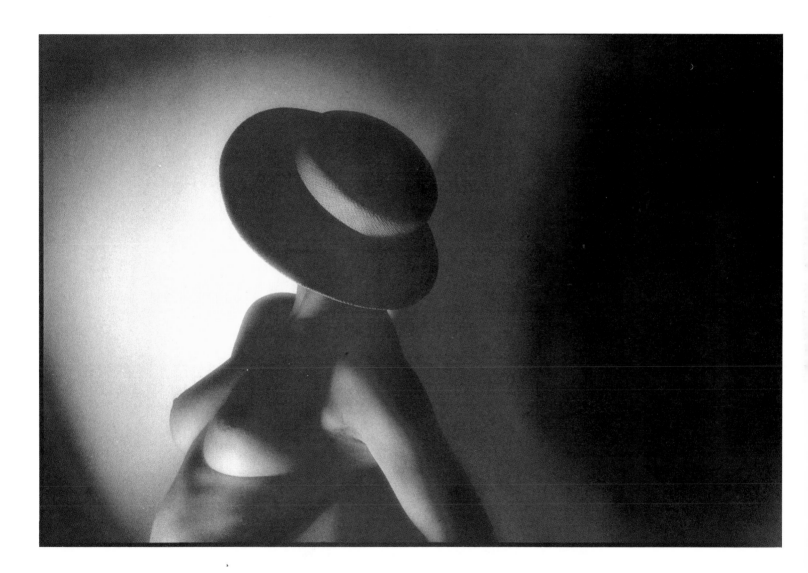

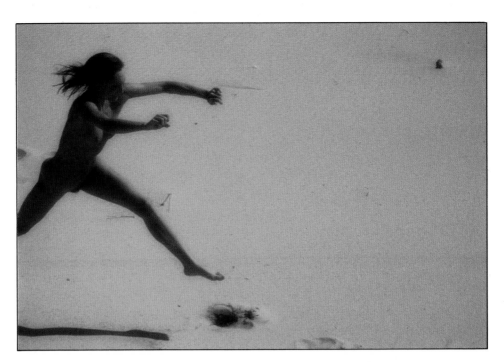

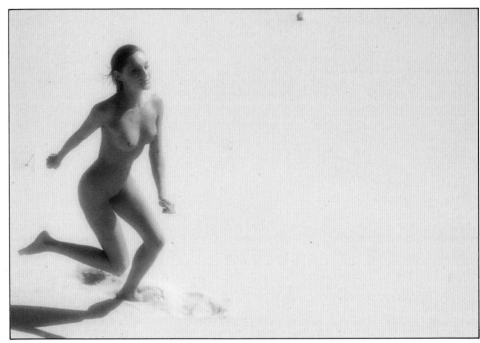

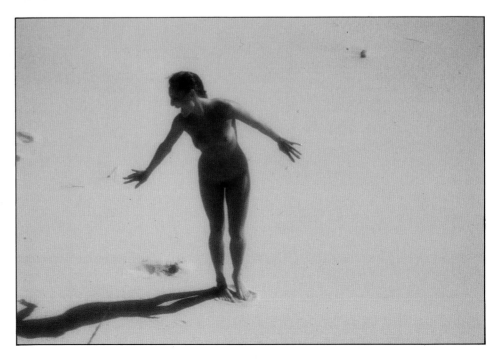

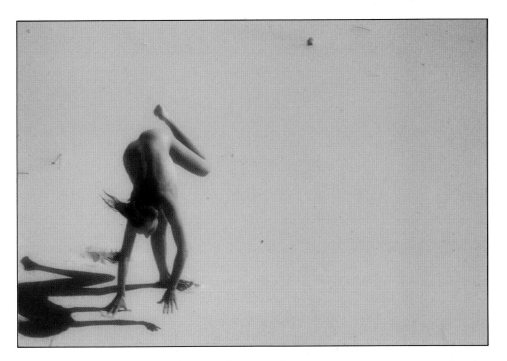

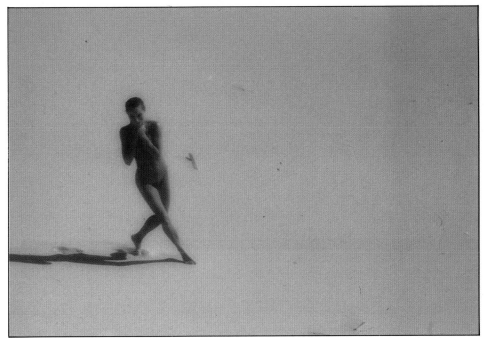

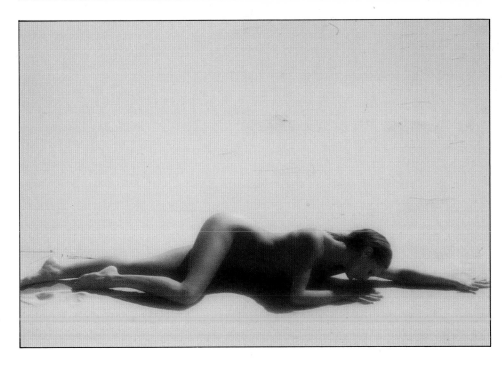

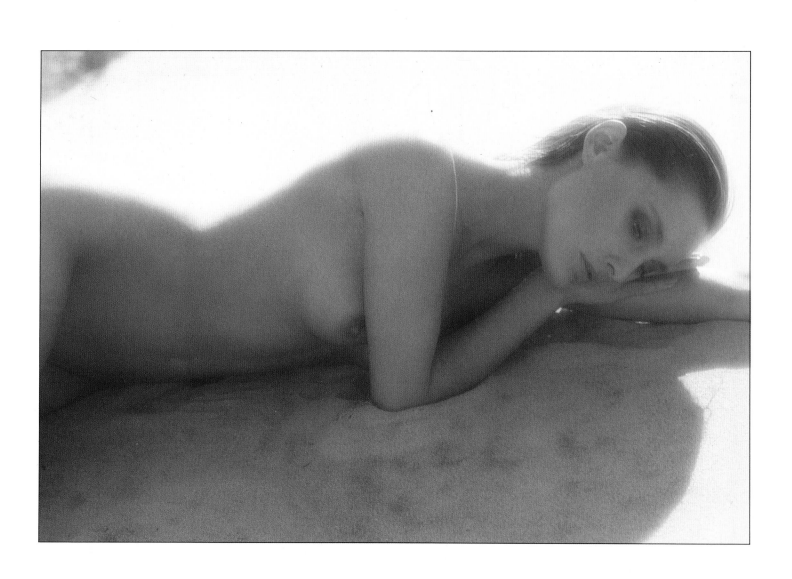

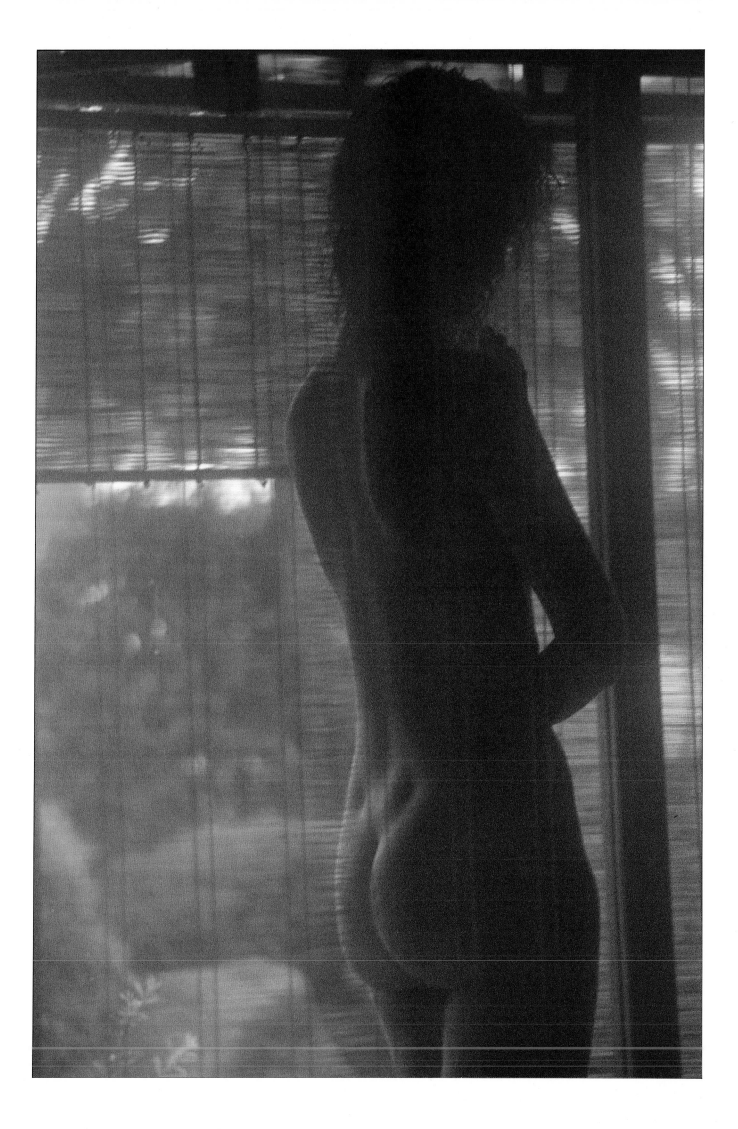

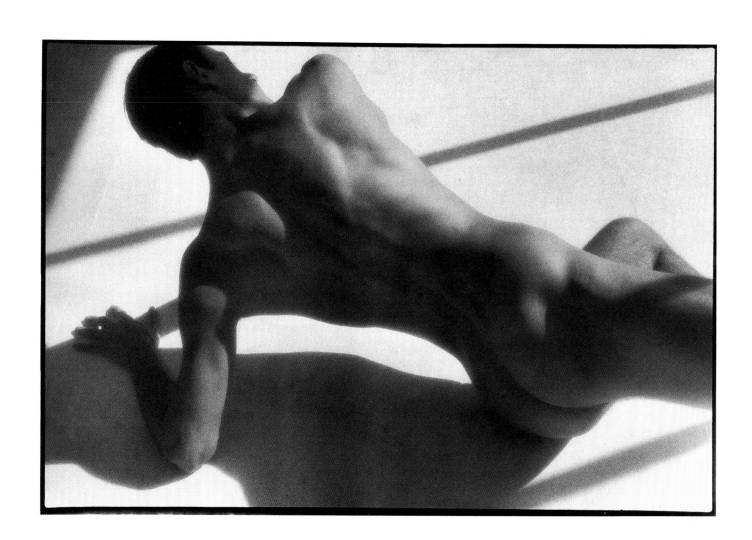

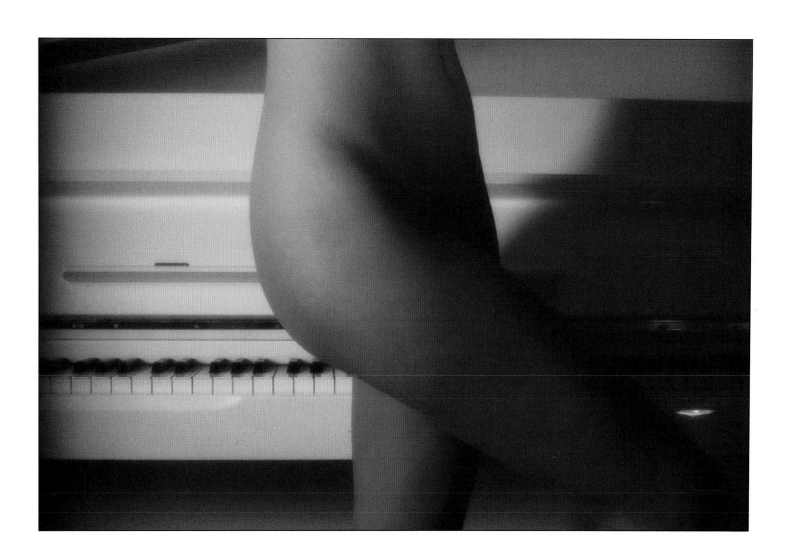

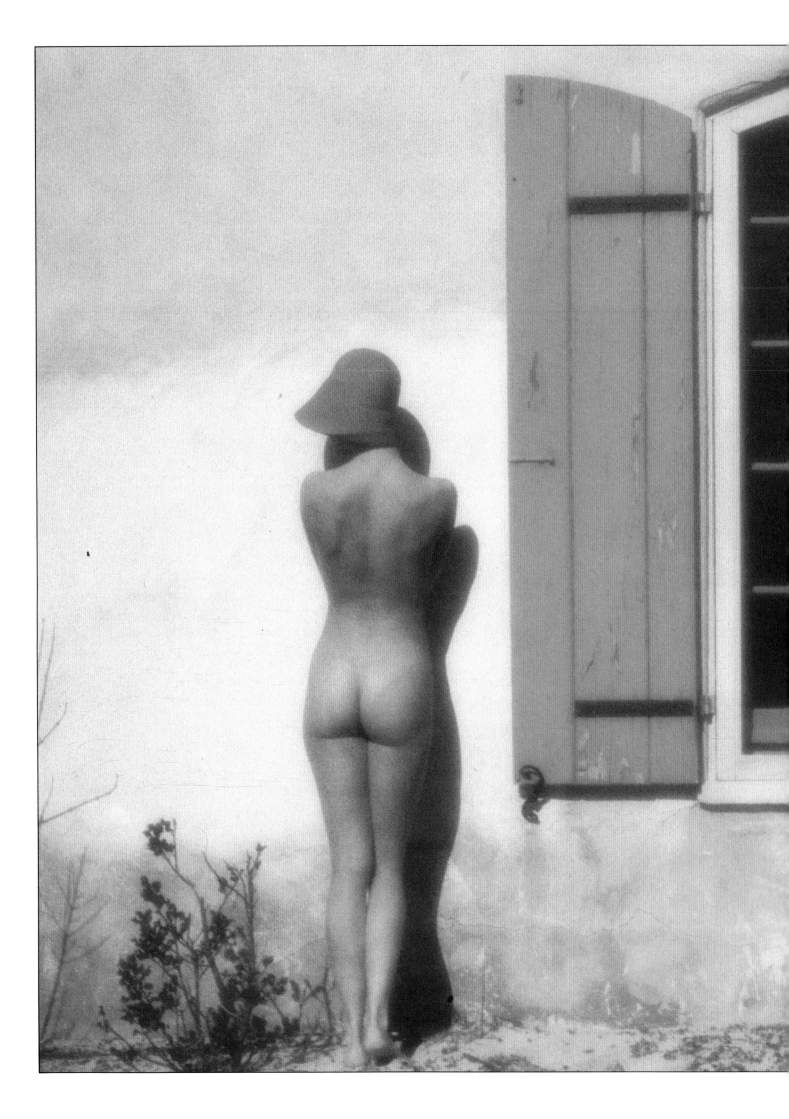

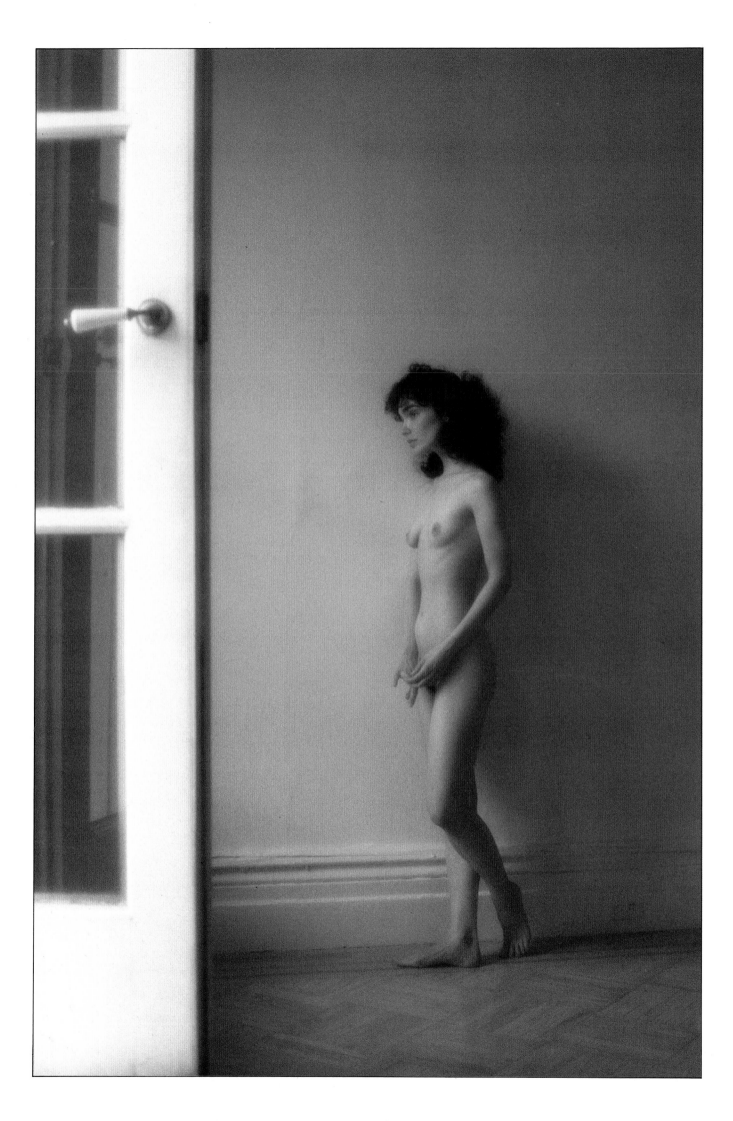

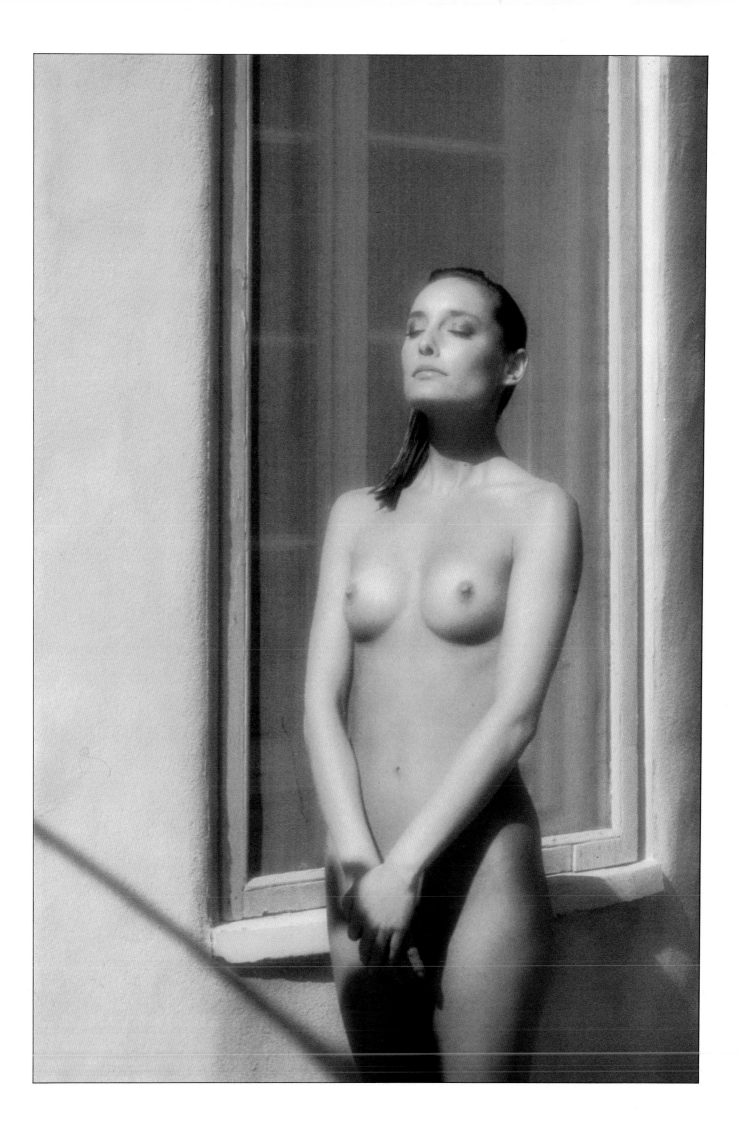

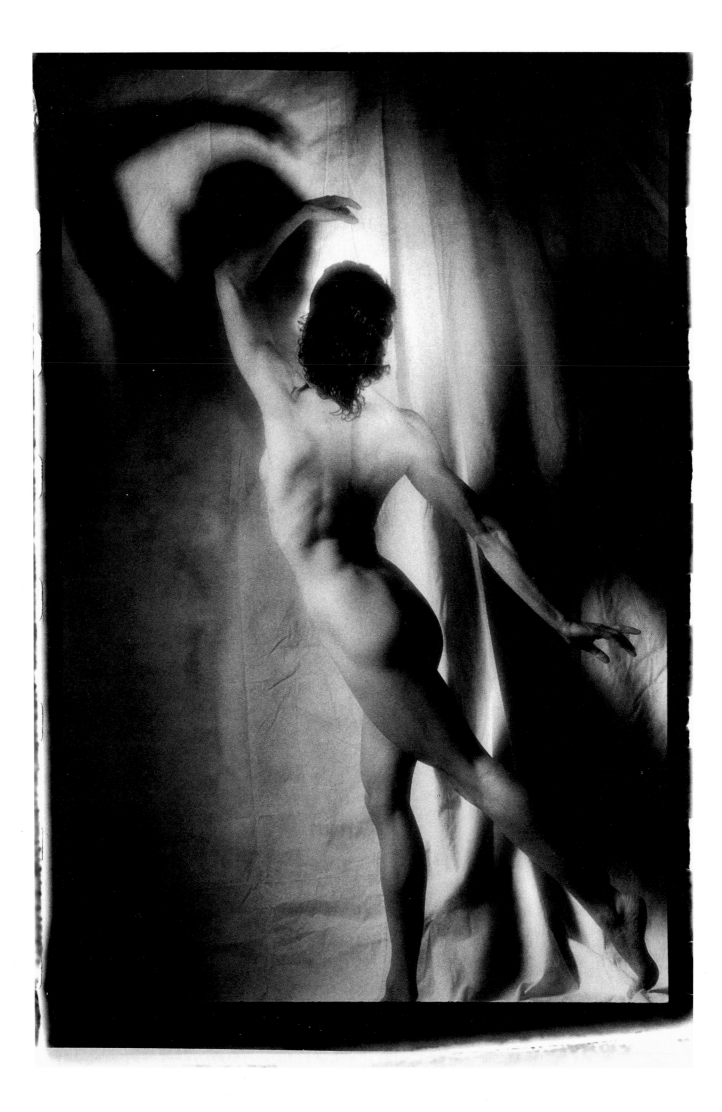

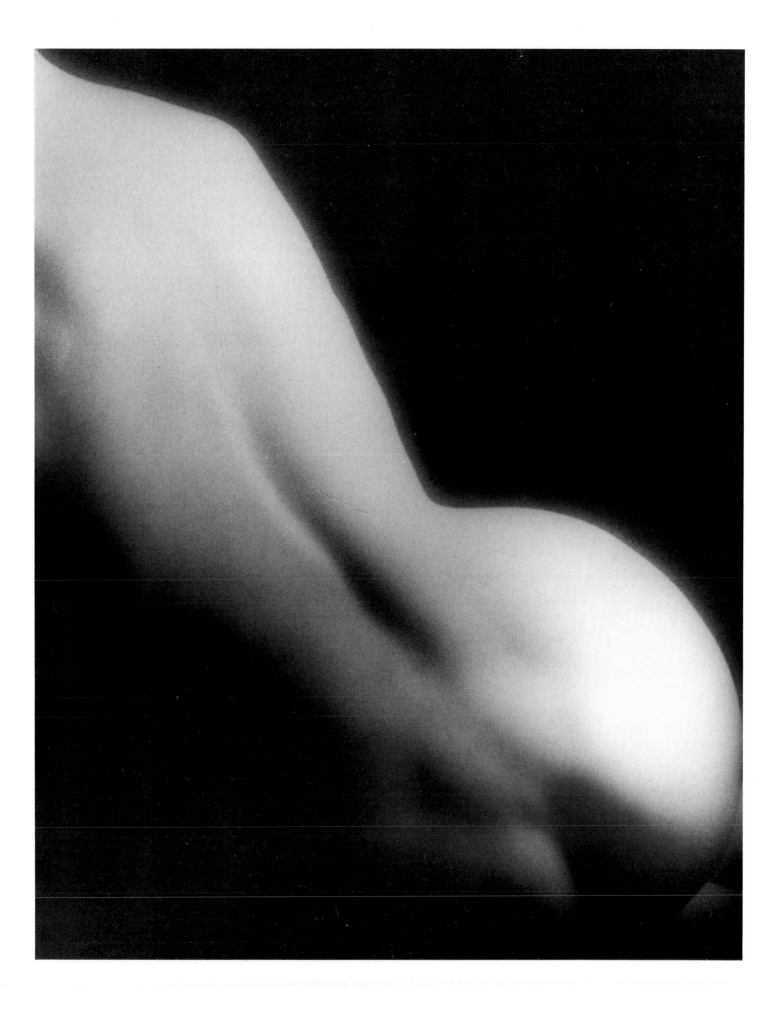

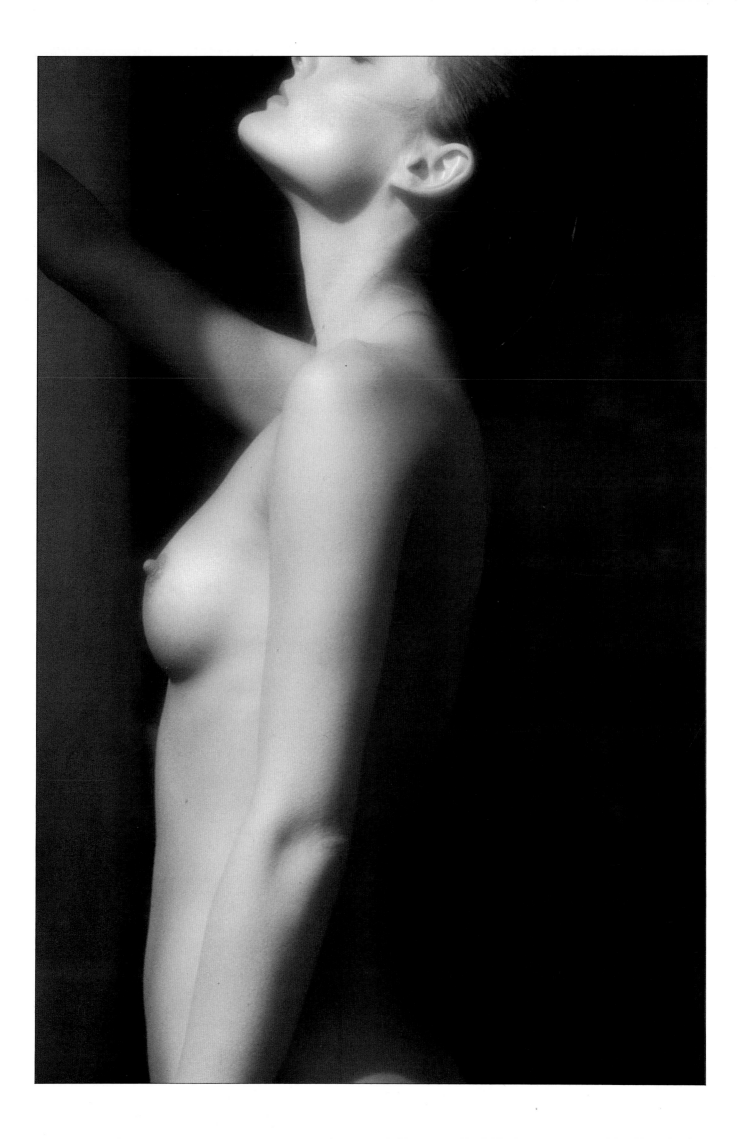

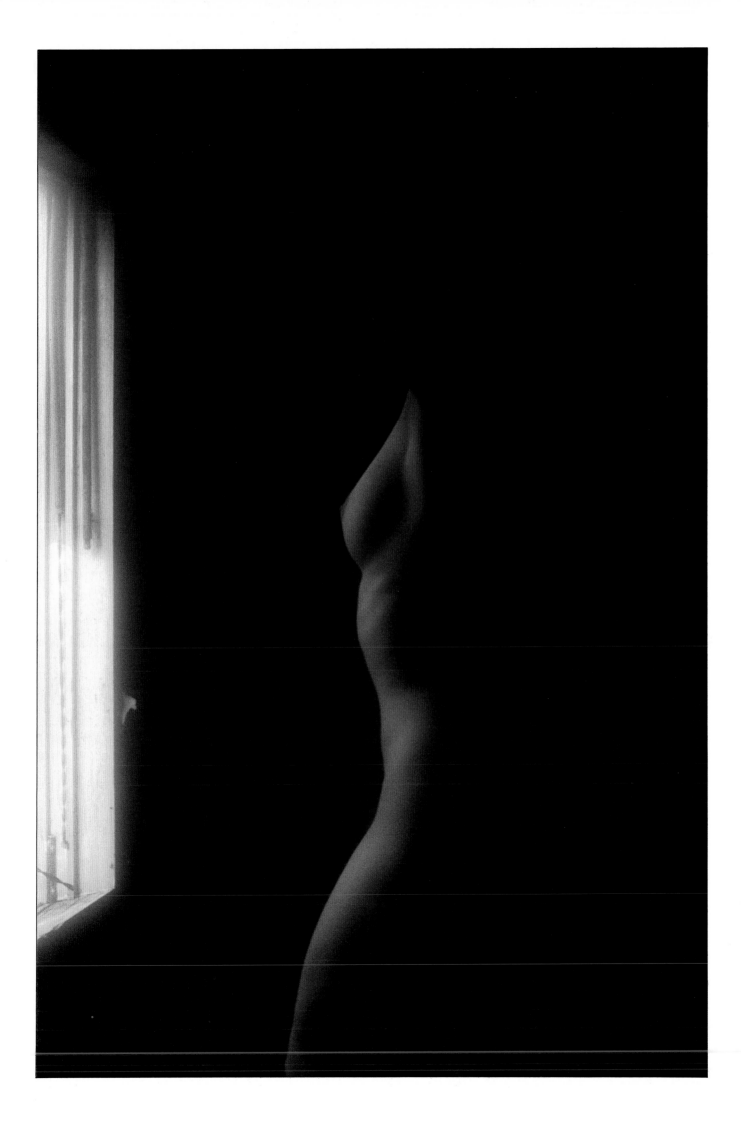

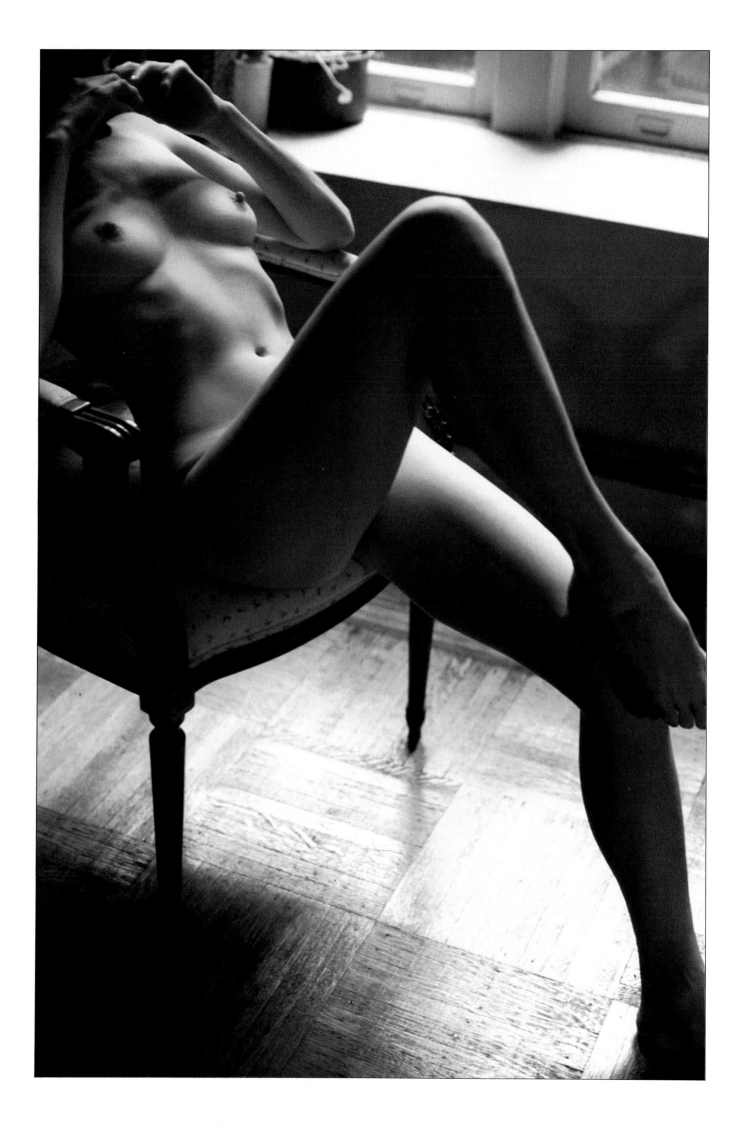

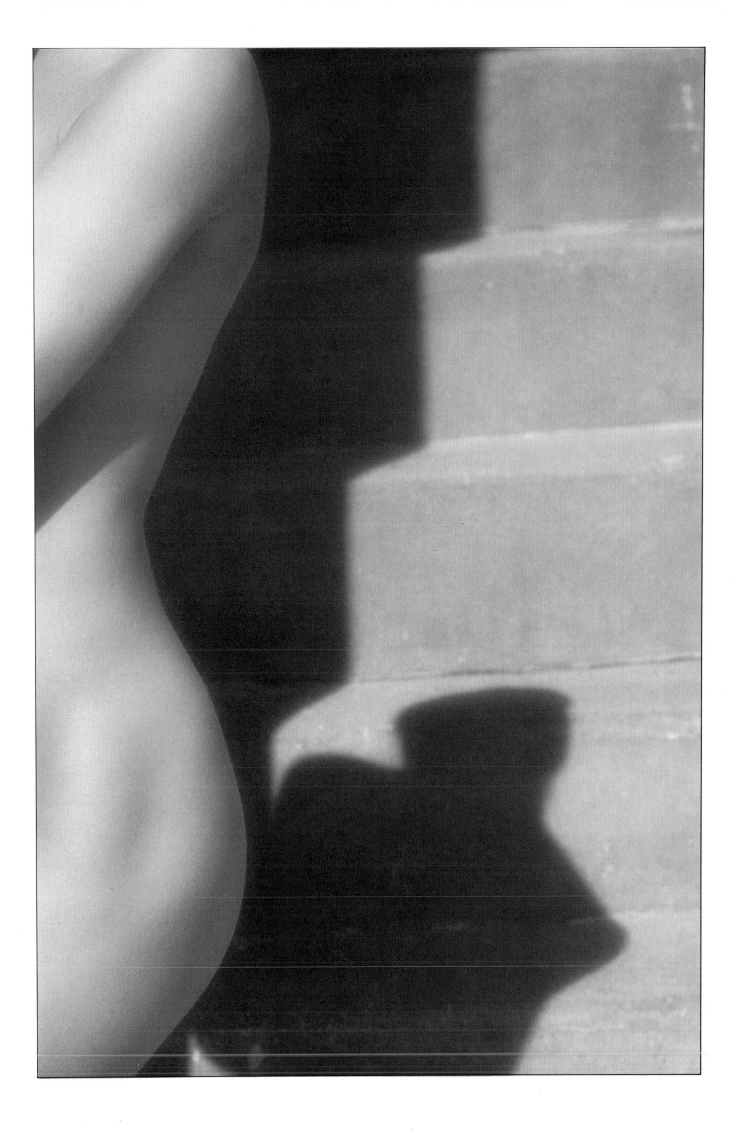

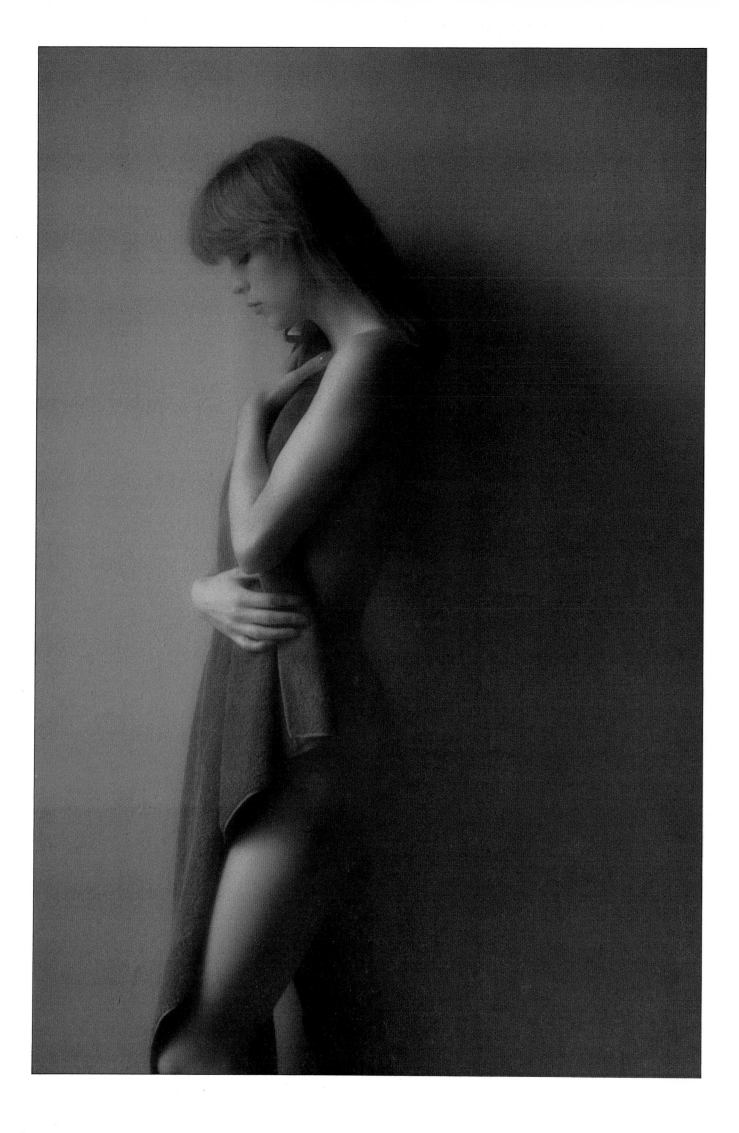

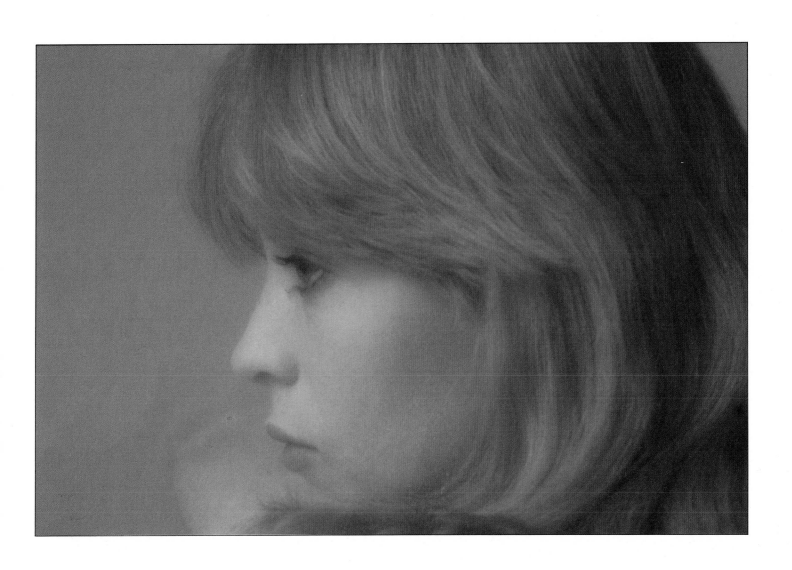

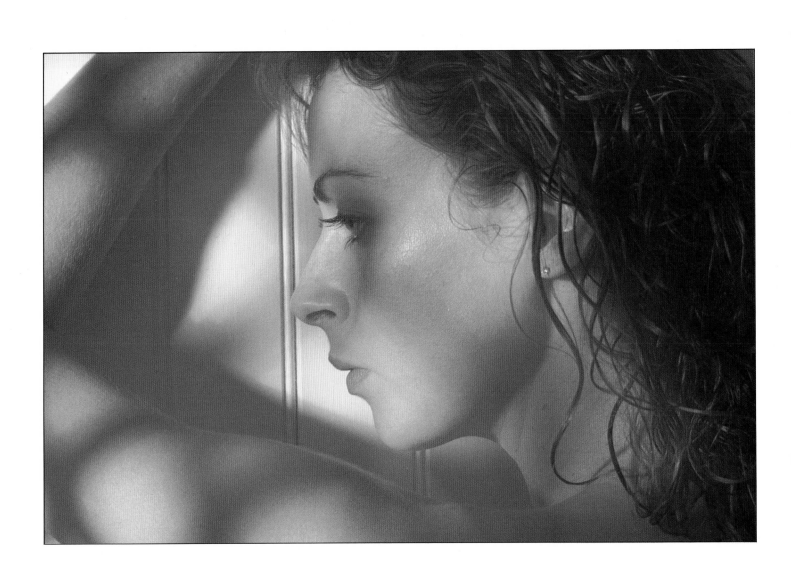

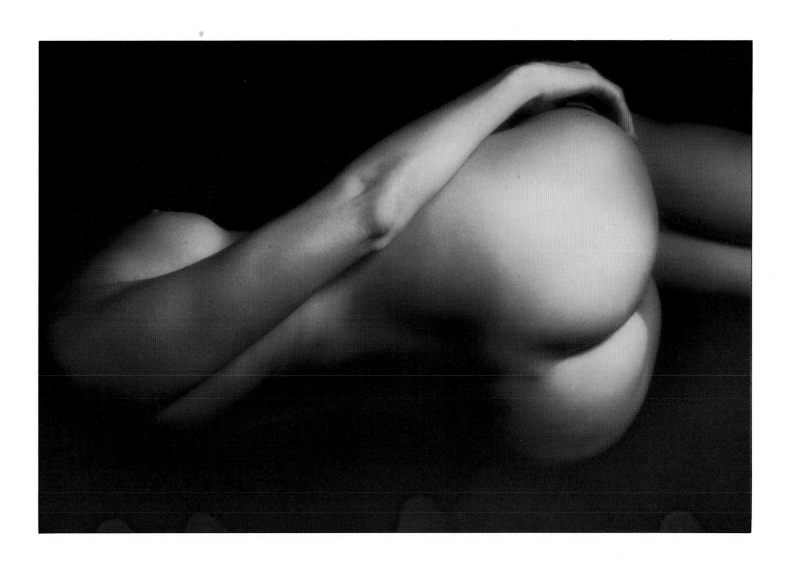

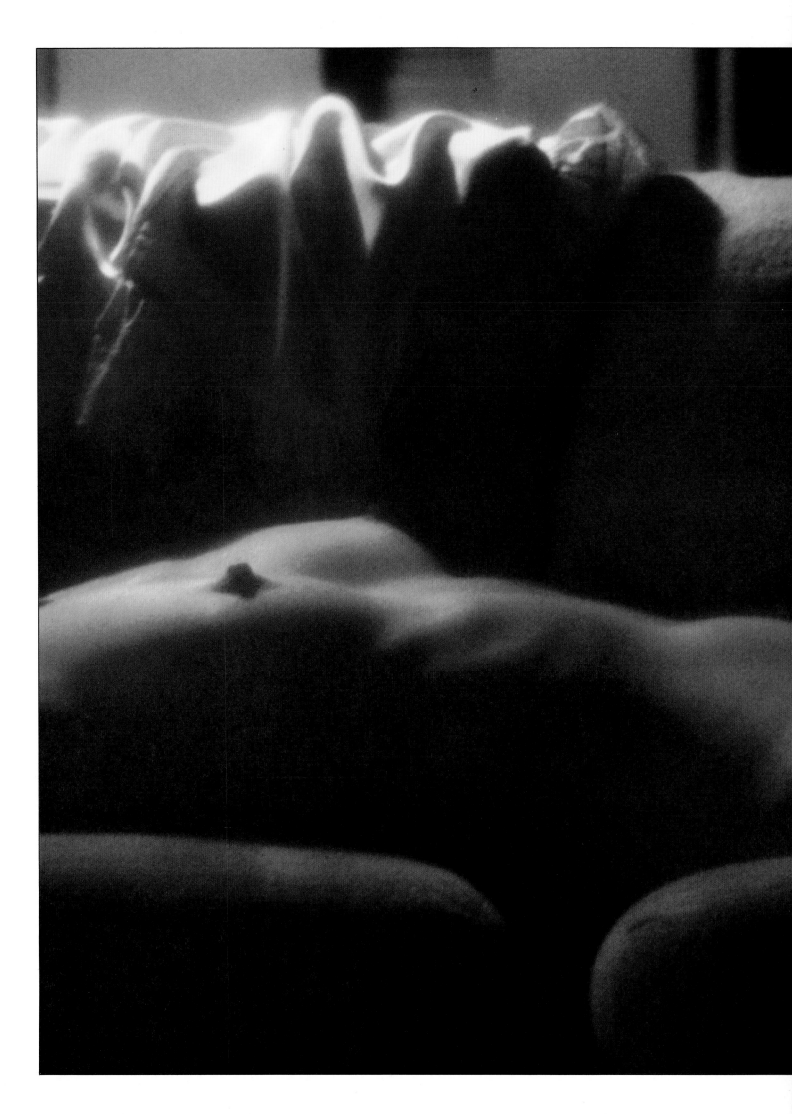

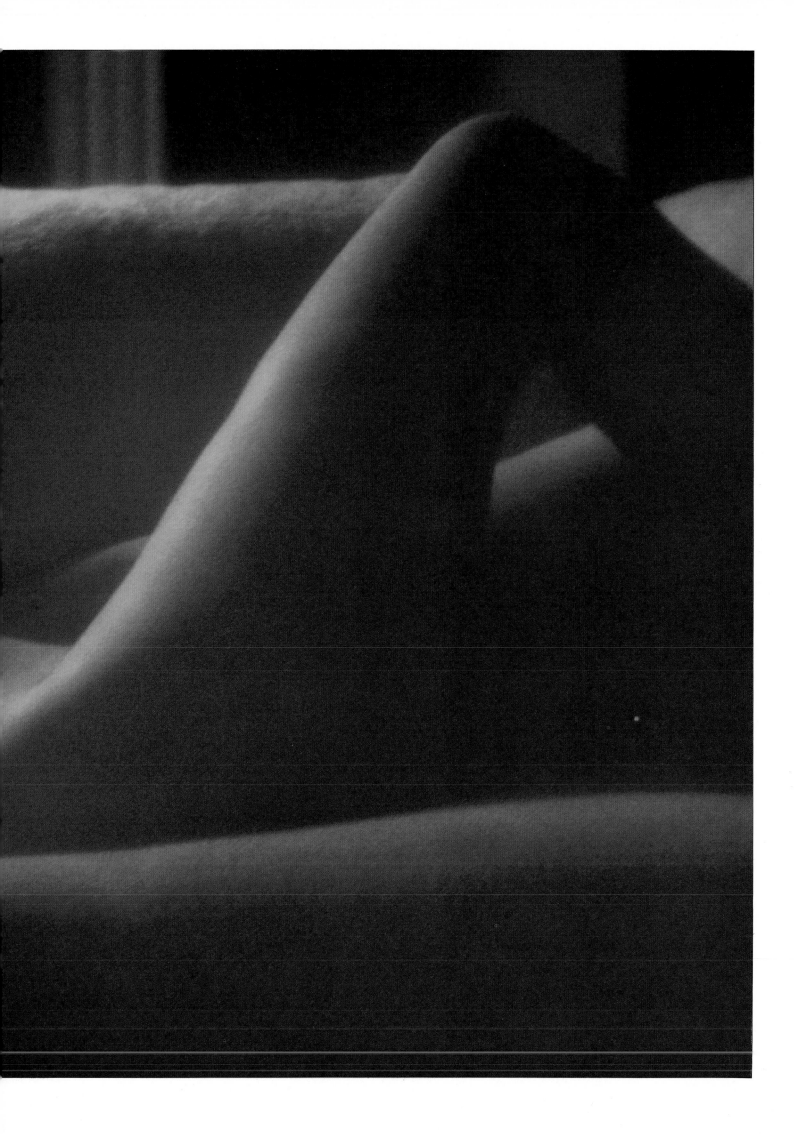

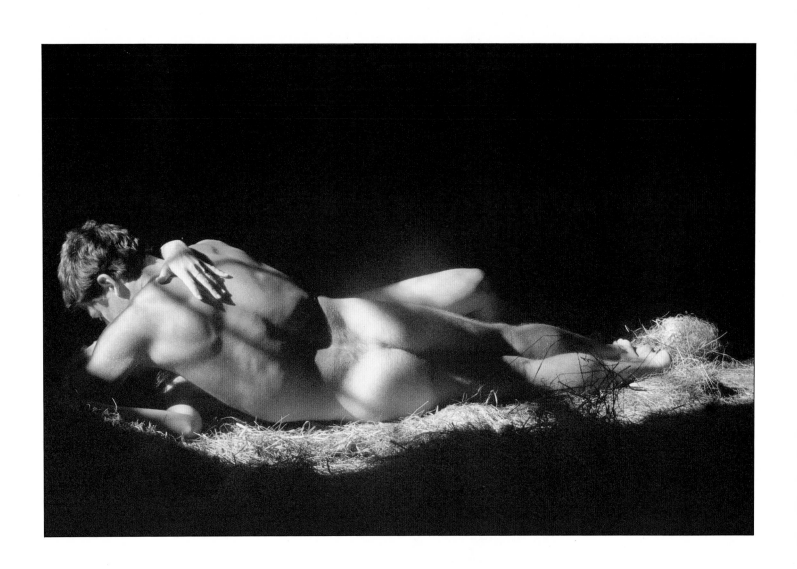

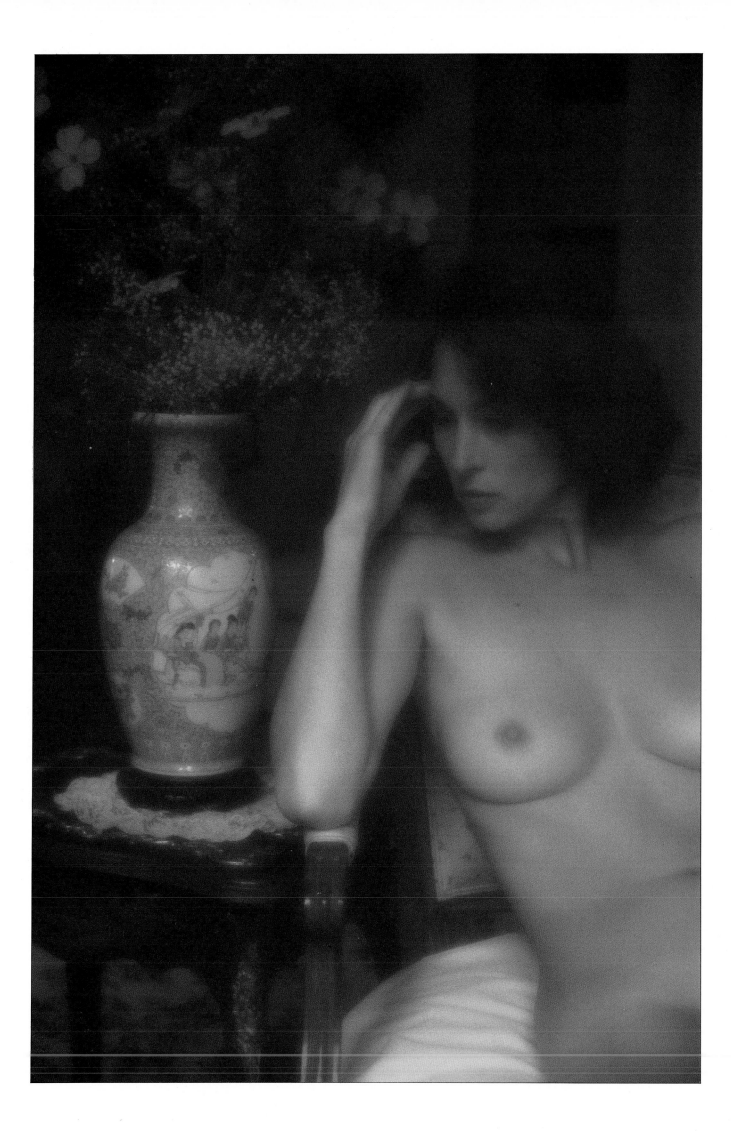

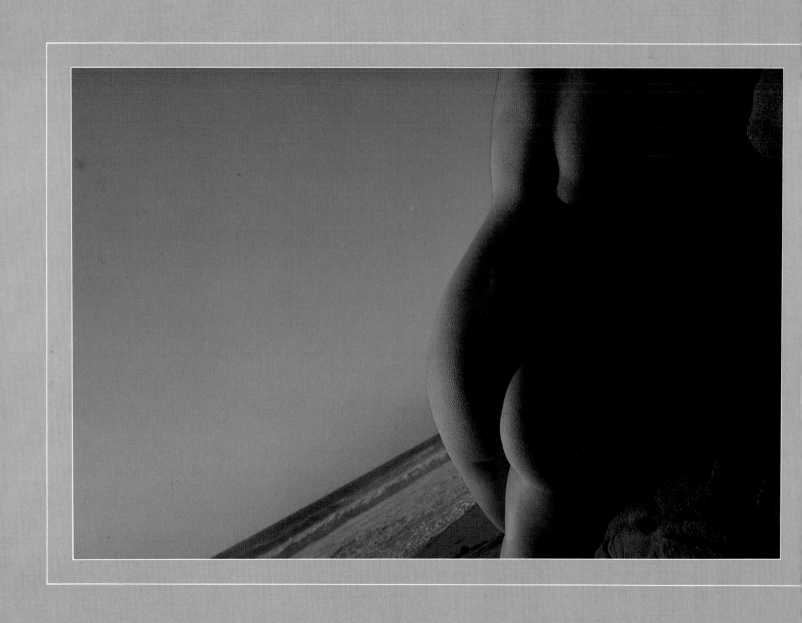

THE
GRAPHIC
NUDE

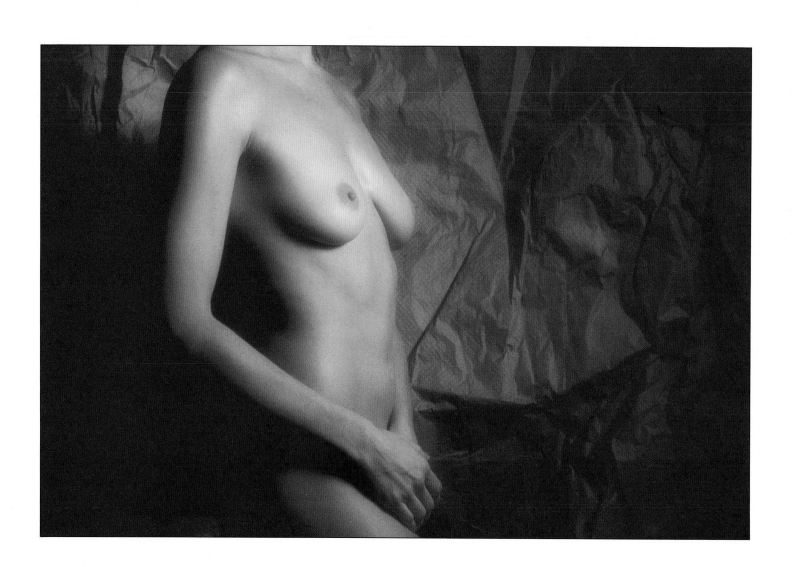

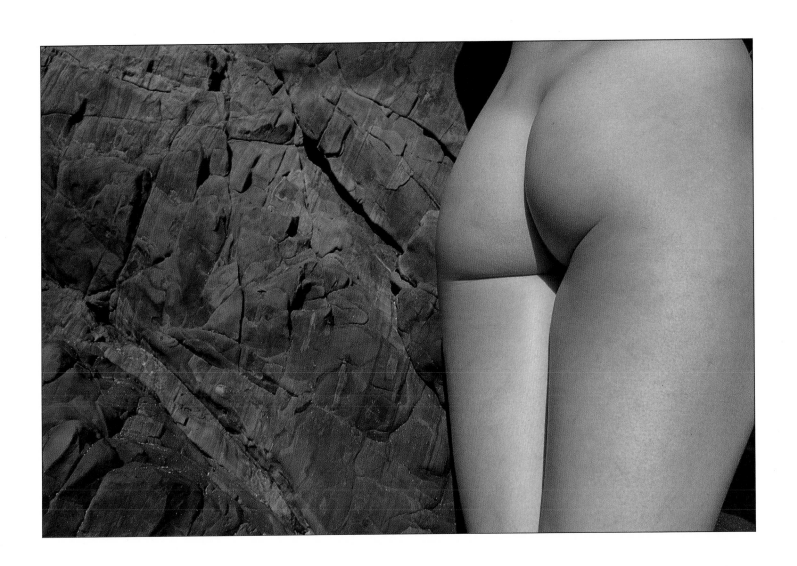

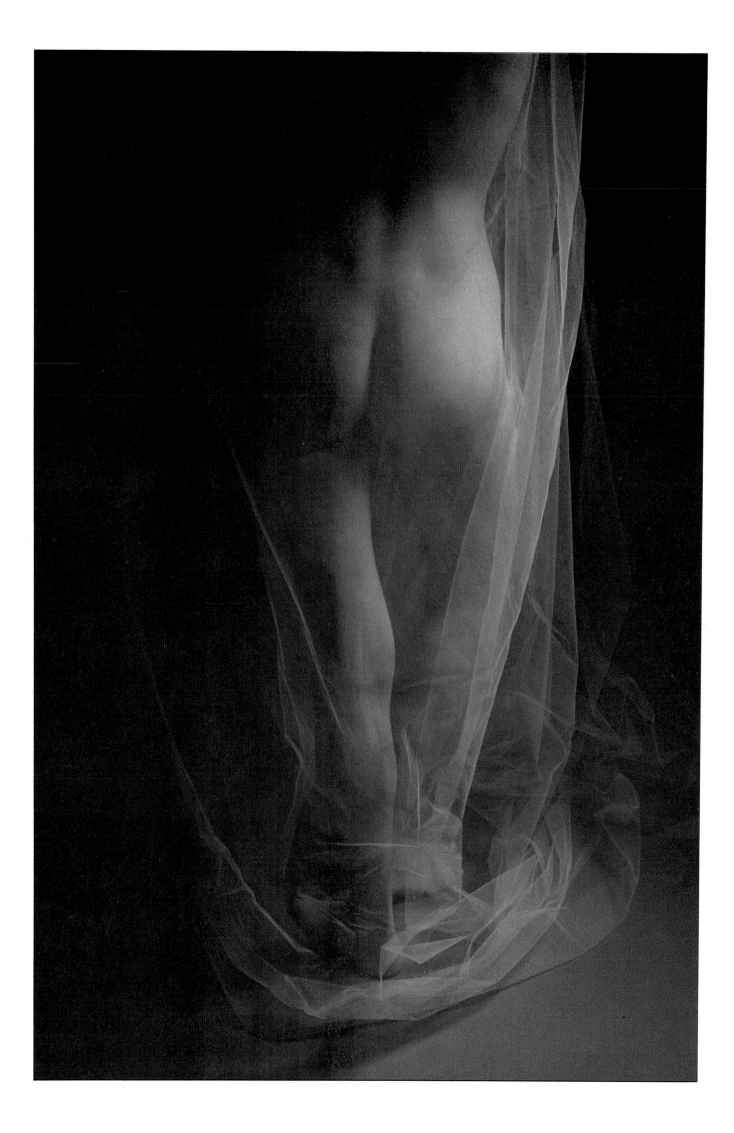

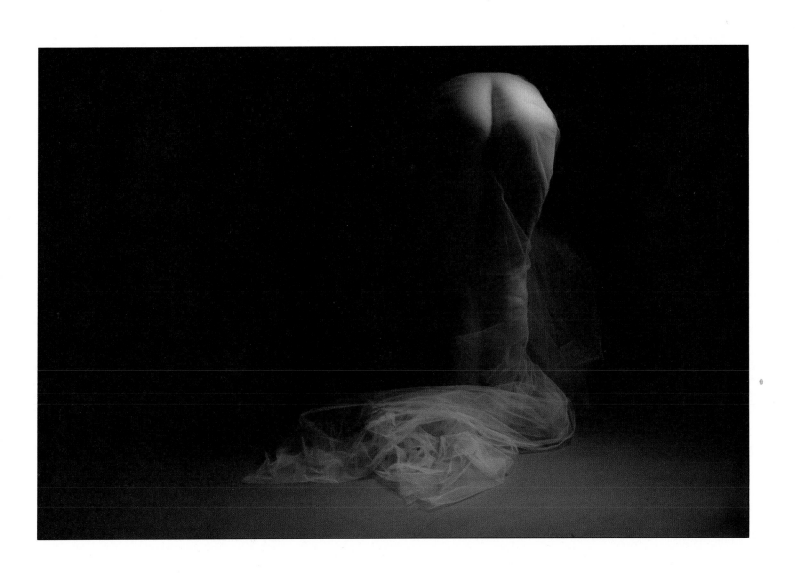

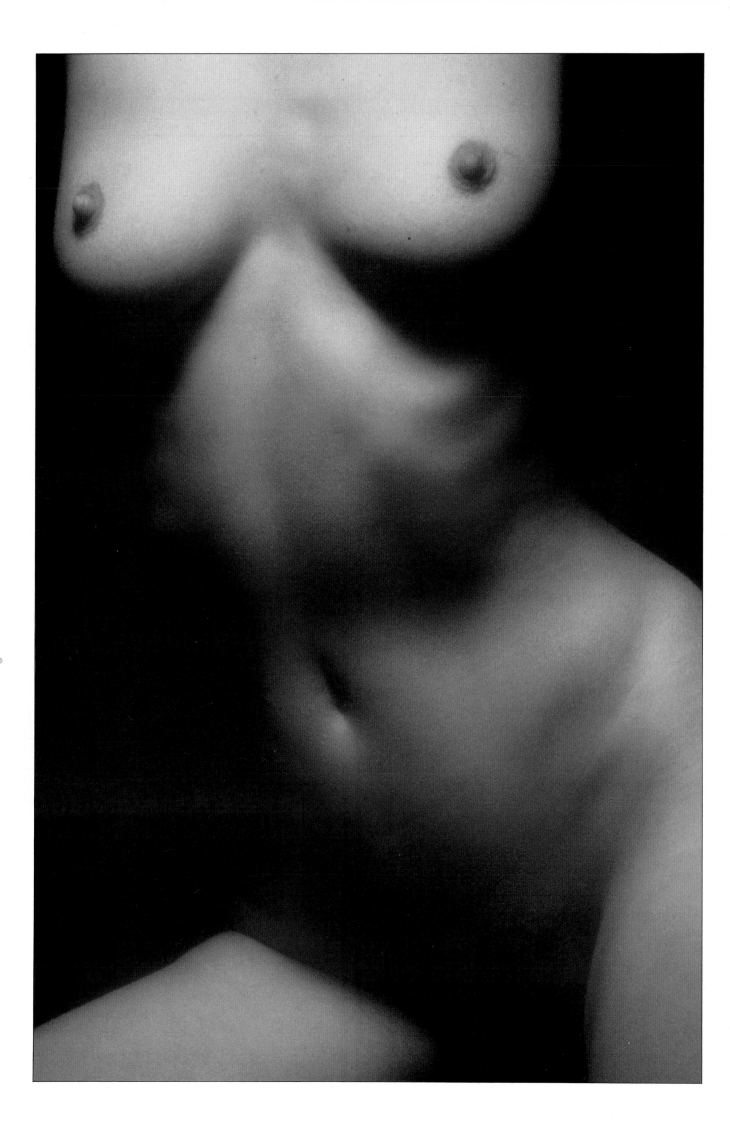

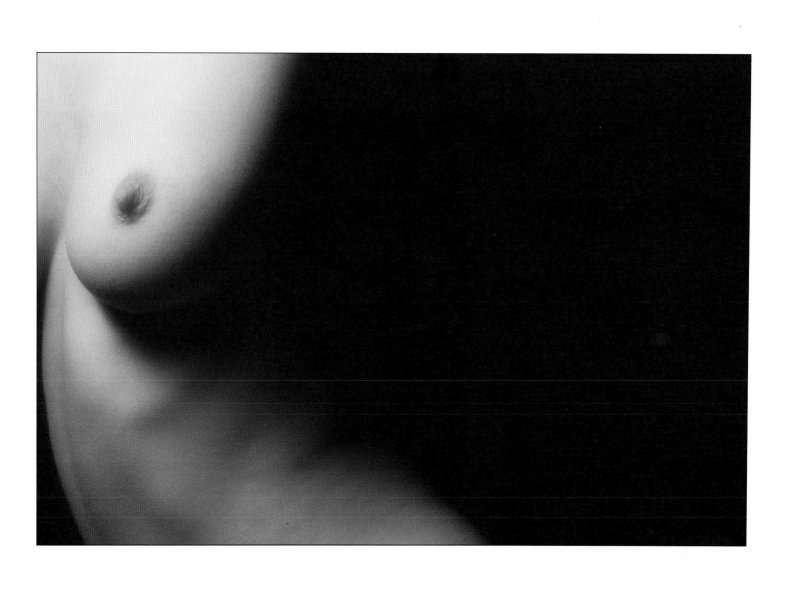

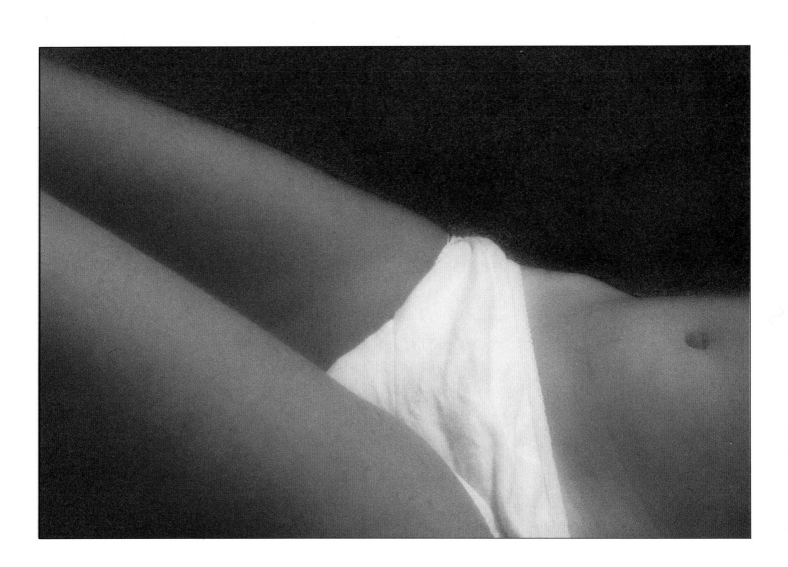

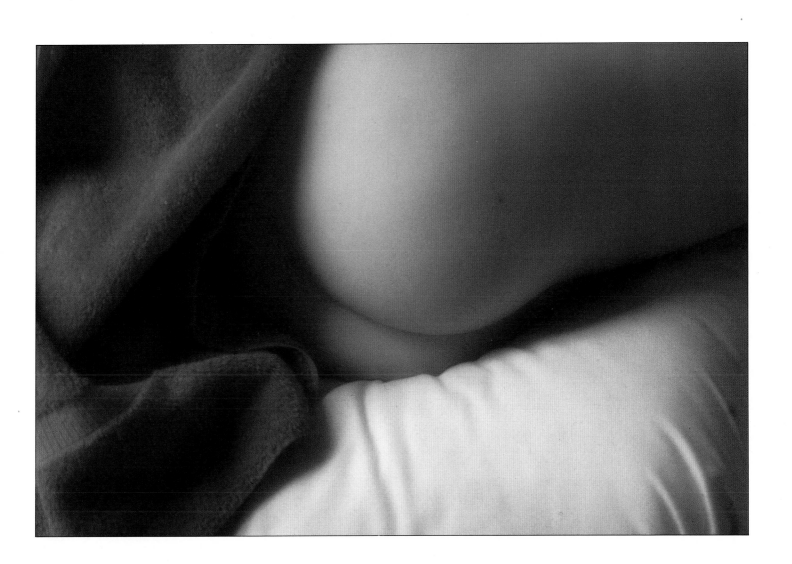

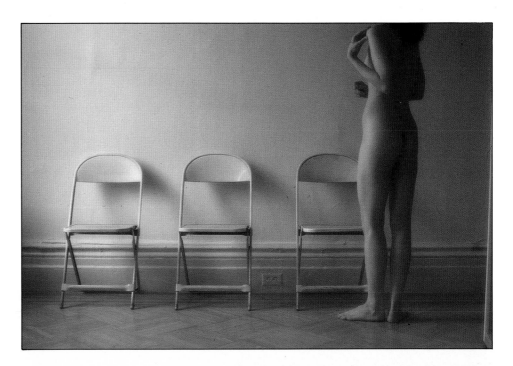

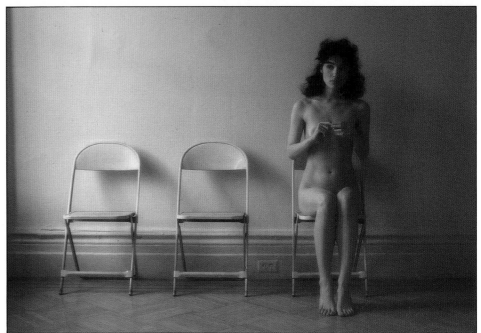

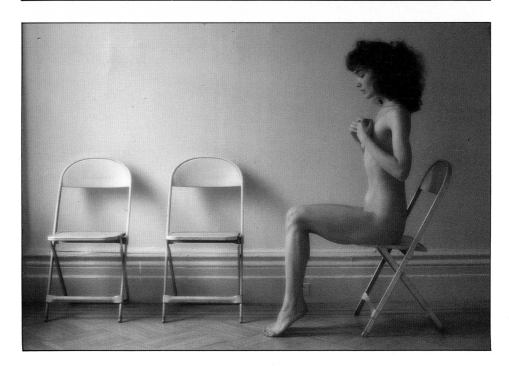

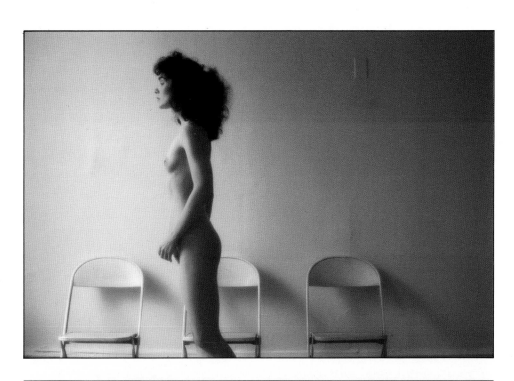

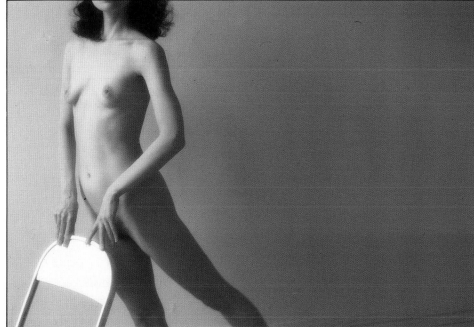

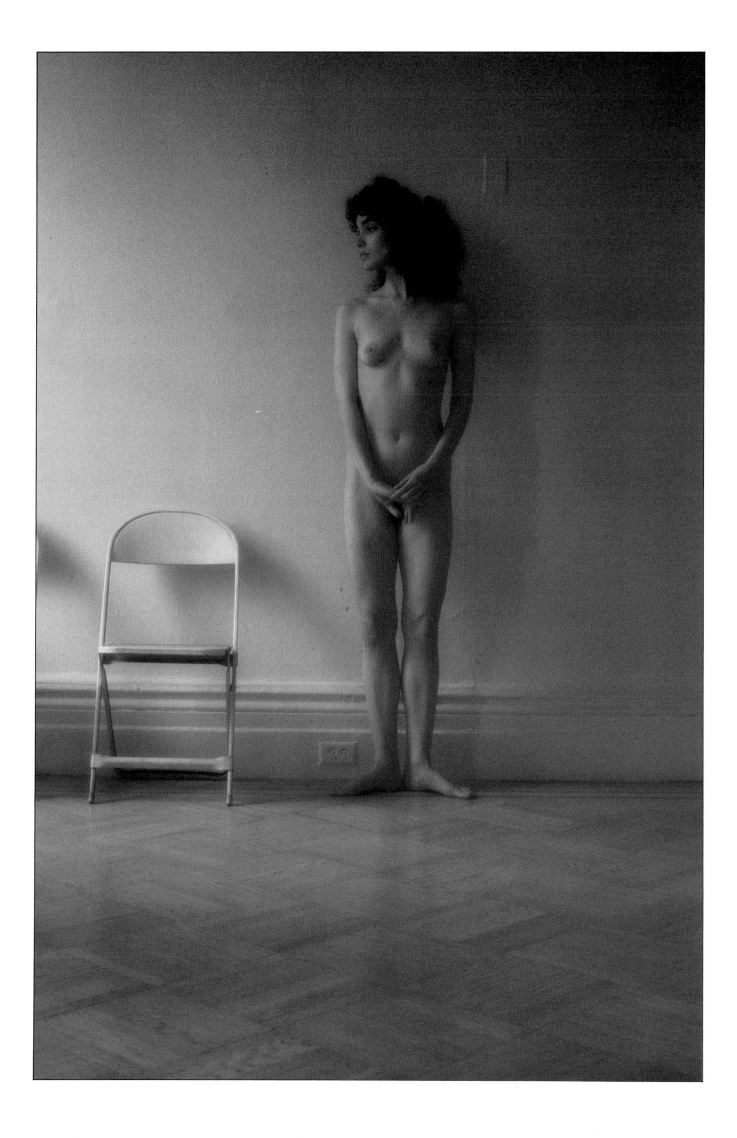

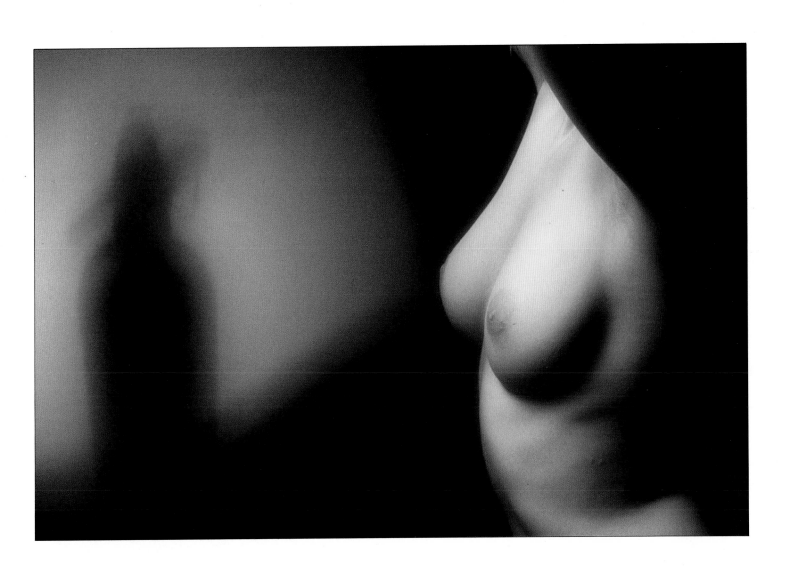

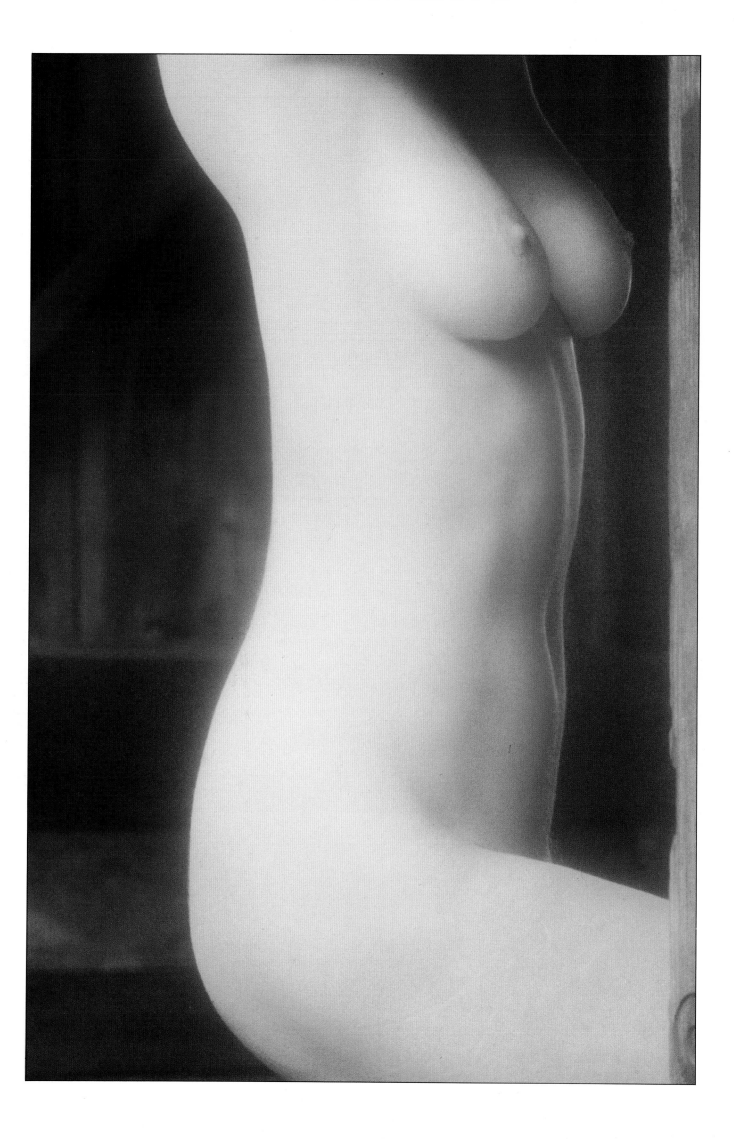

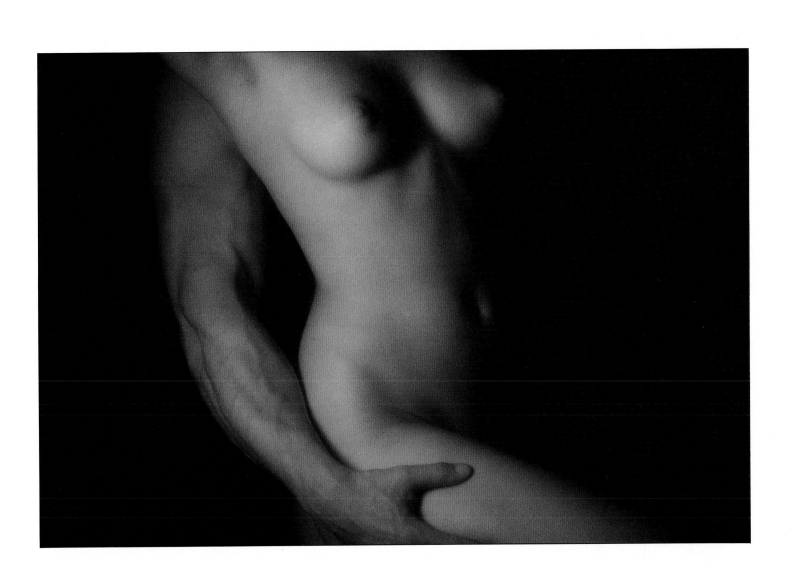

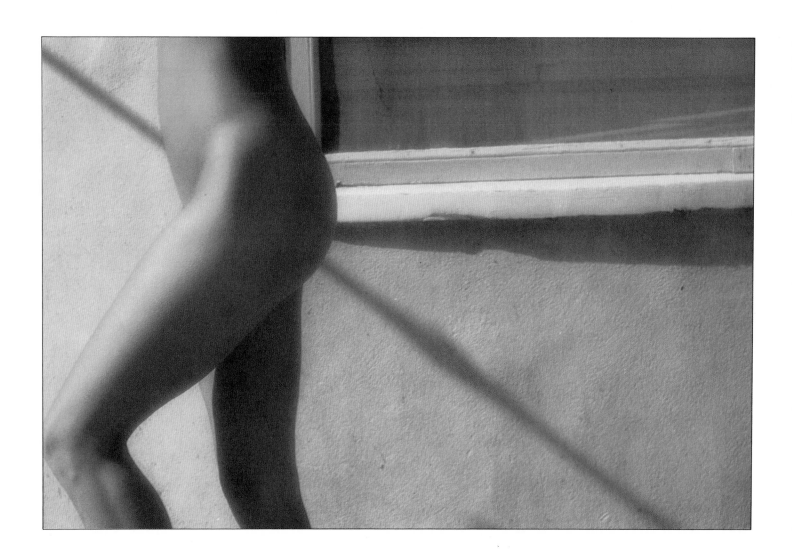

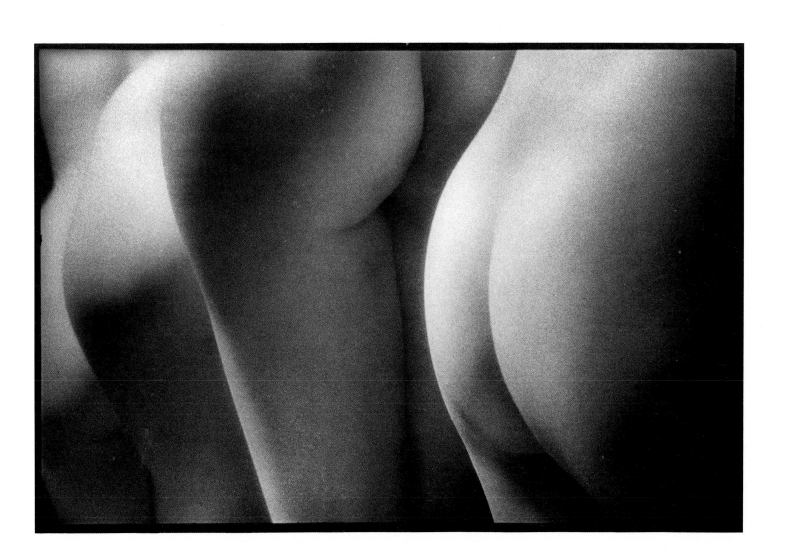

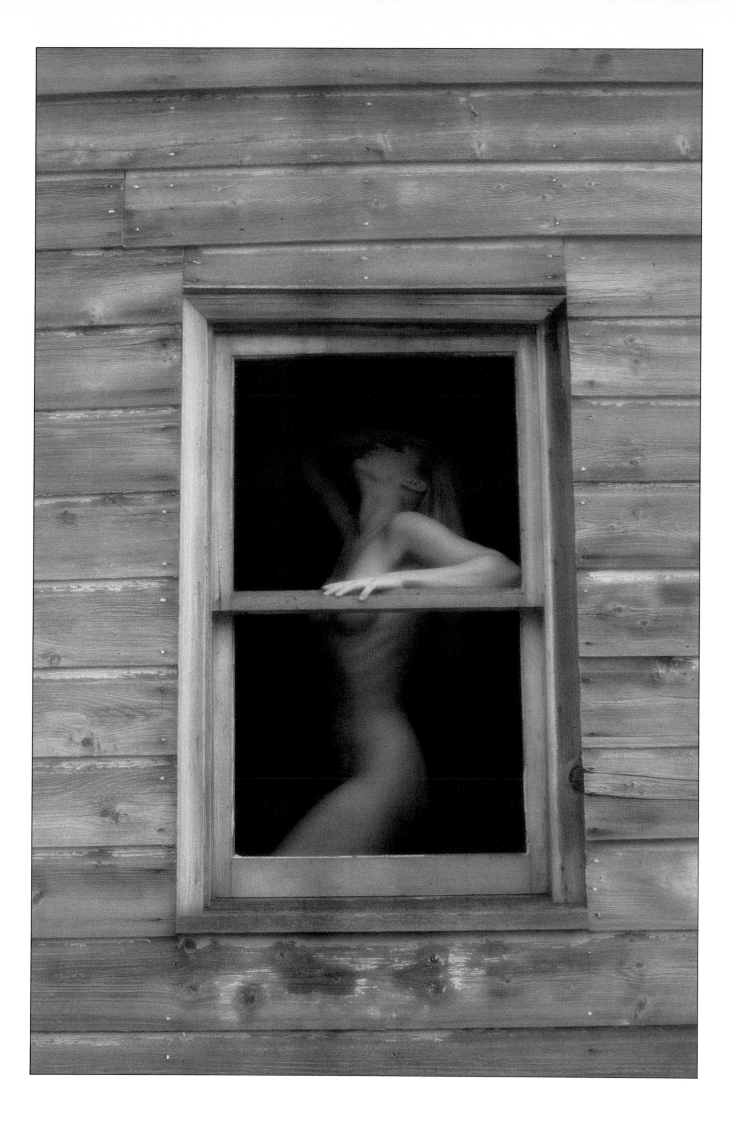

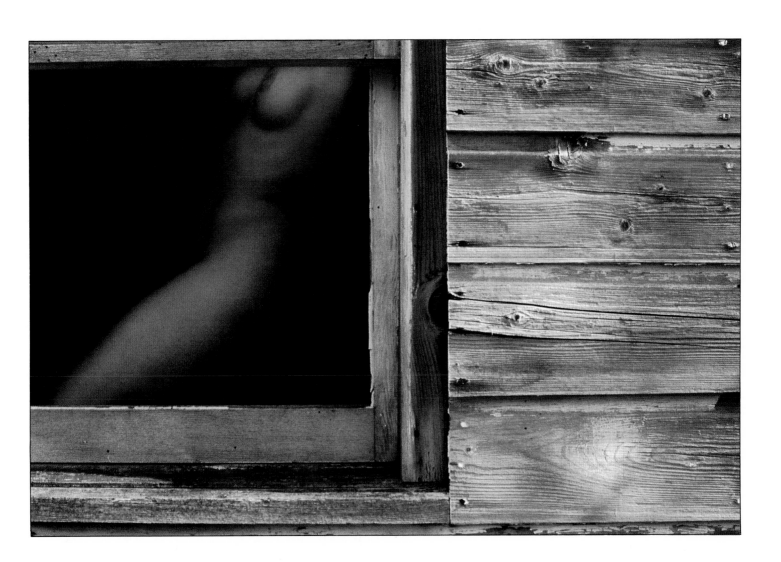

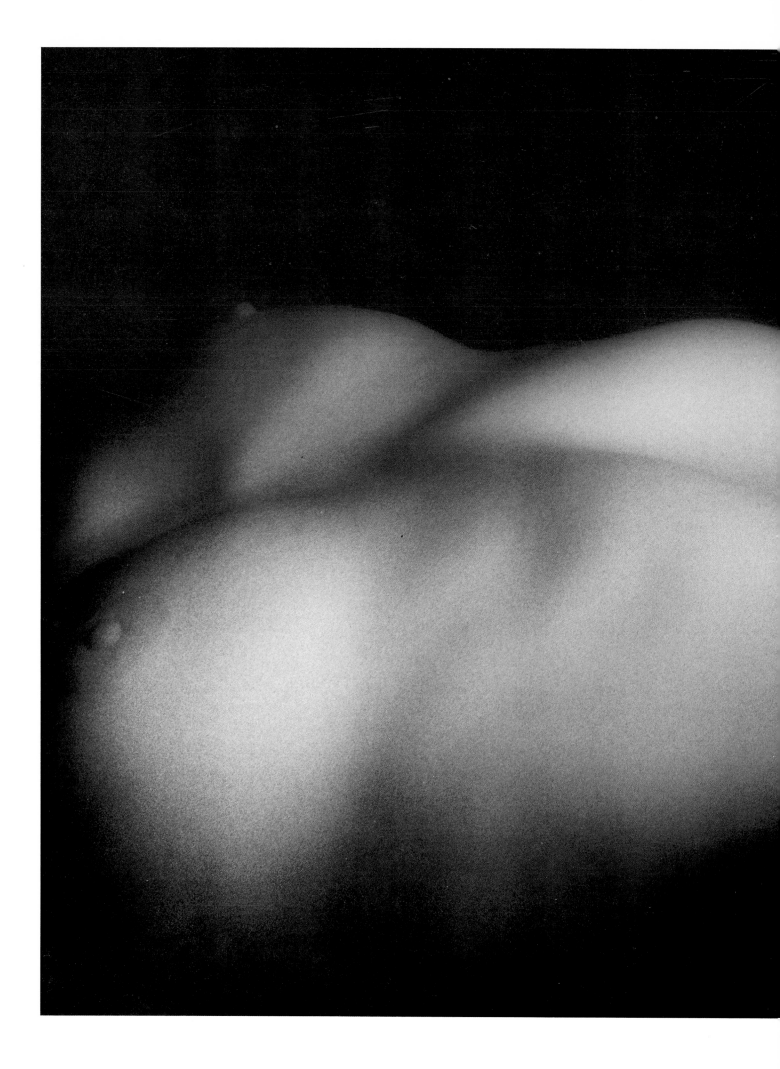

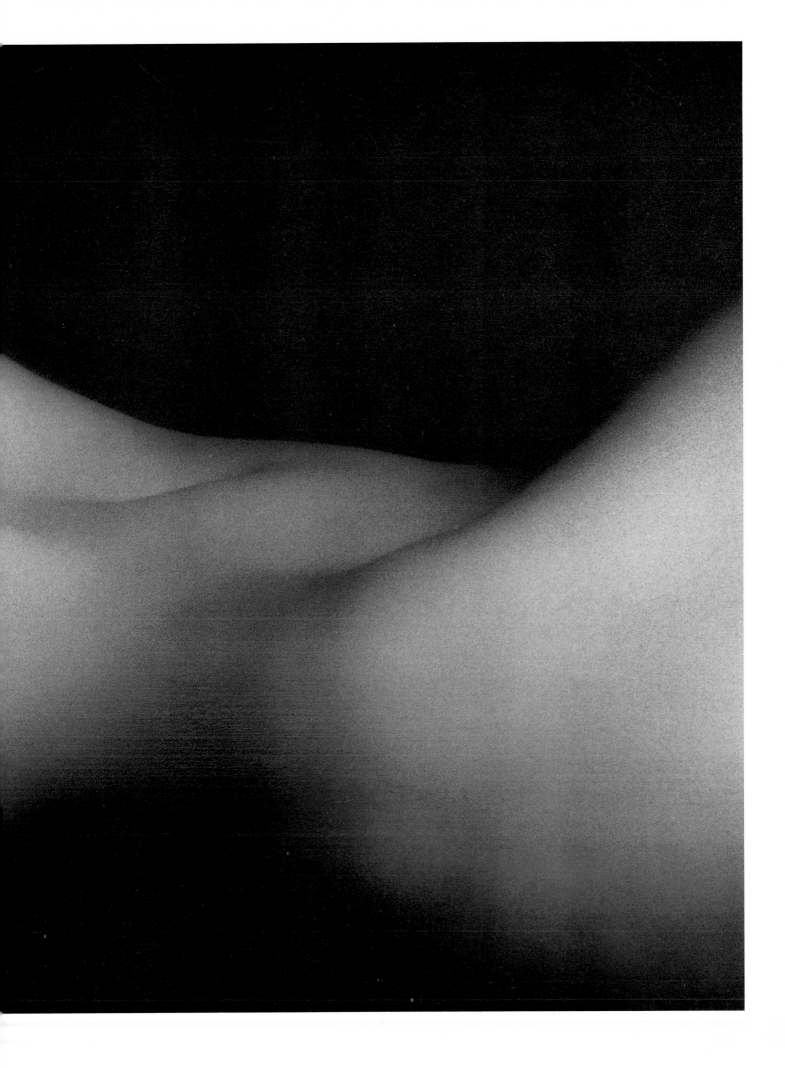

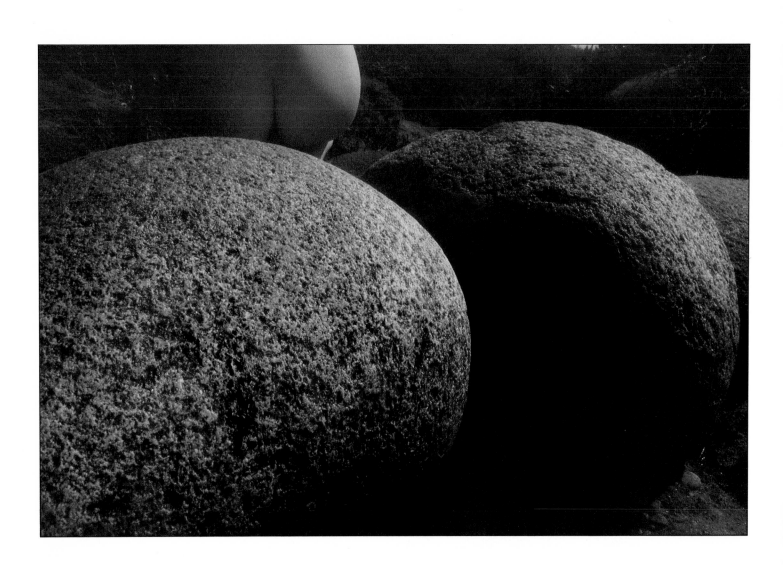

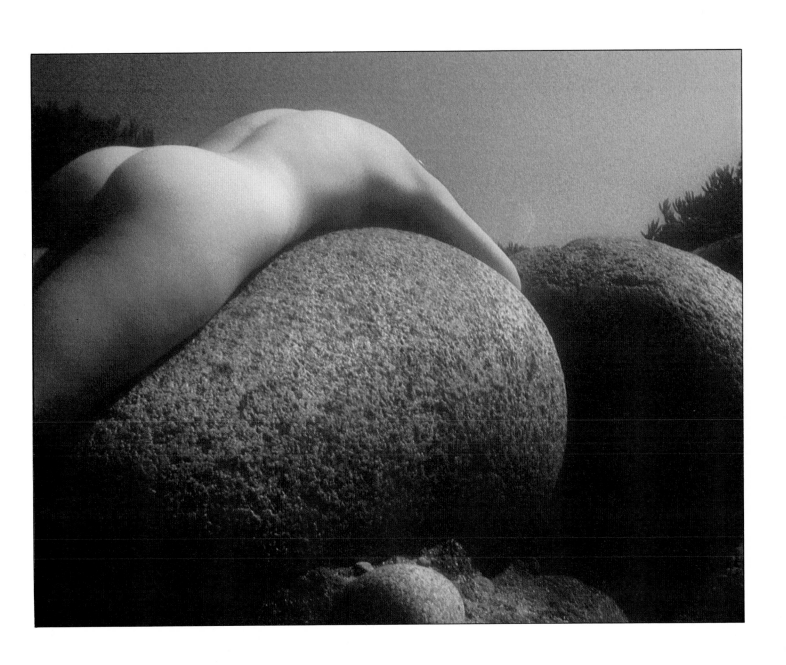

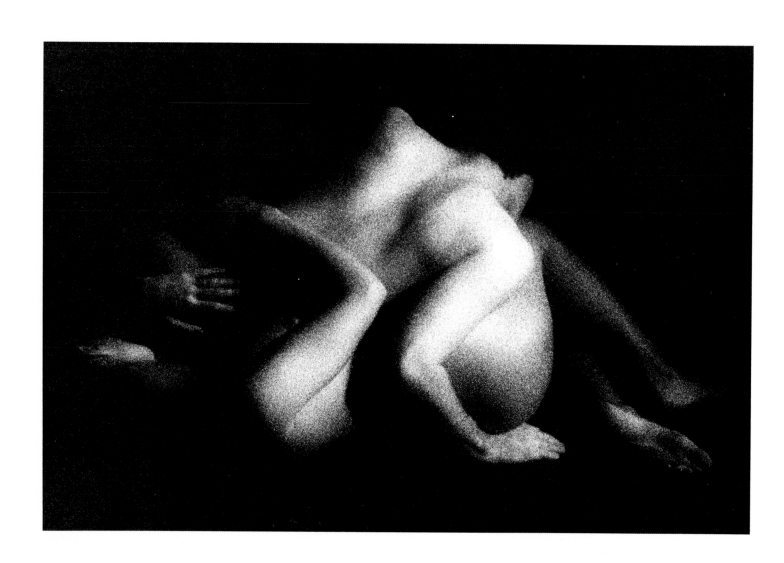

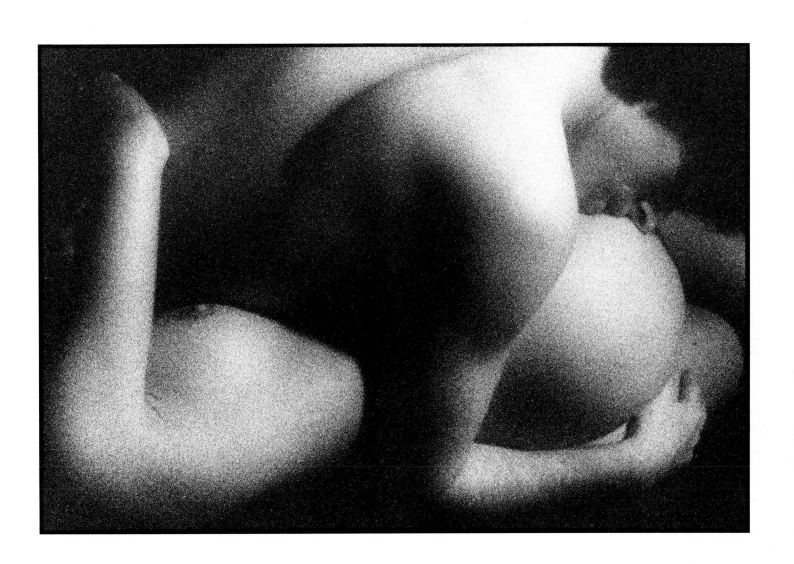

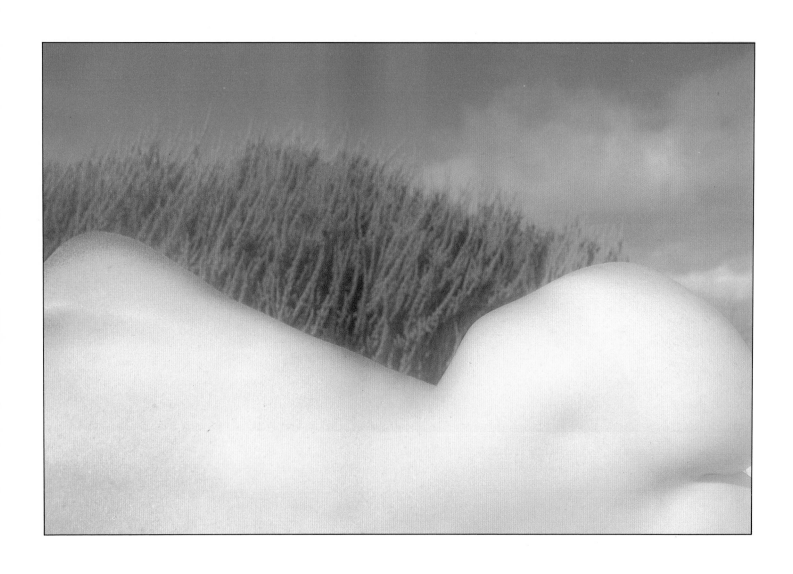

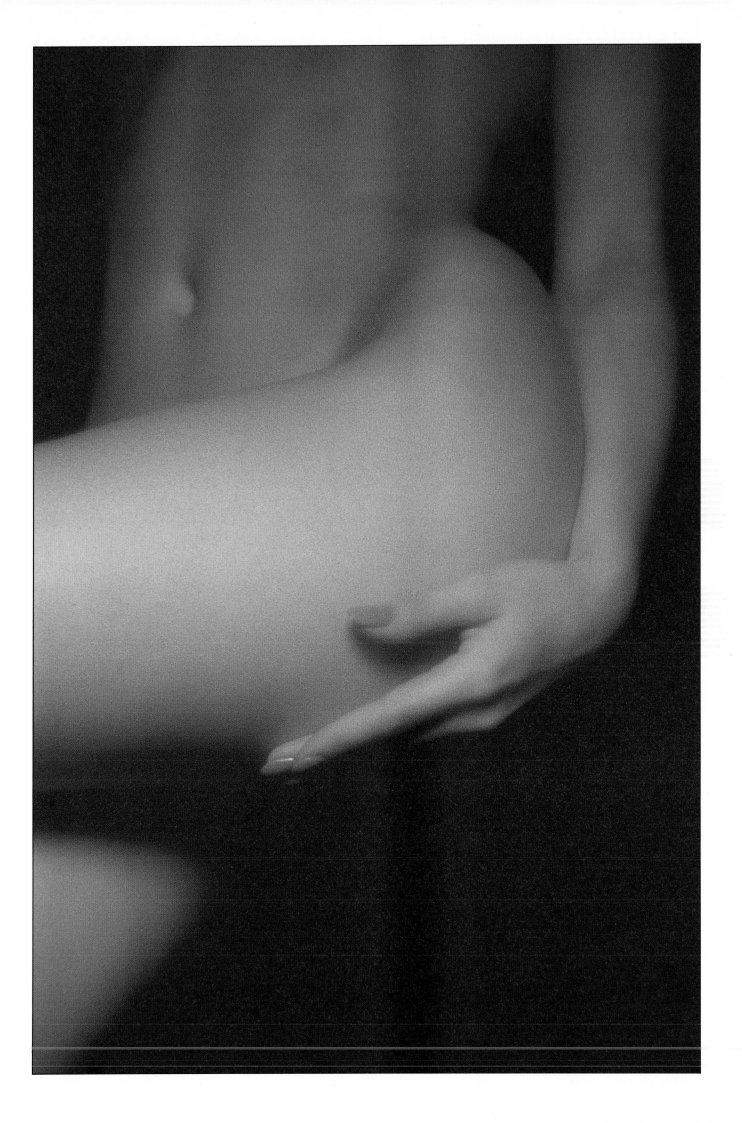

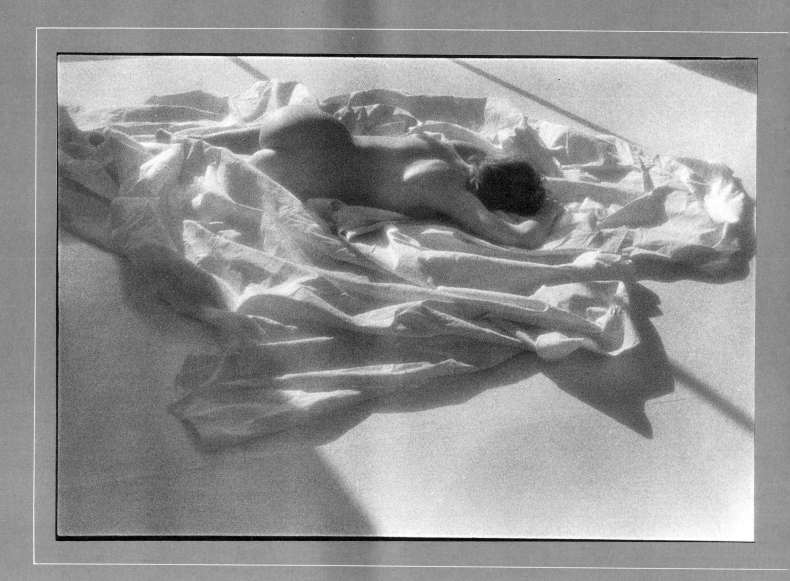

NOTES ON THE PHOTOGRAPHS AND TECHNIQUES

Soft box with grid
as fill light

Minolta X 700 with
50 mm lens

B&W film (infra-red)
printed on Agfa
Portriga #3 paper
(for warmer tone)

a male nude in a
new way –
one with a classic,
sculptural feel, yet
highly stylized

Spot strobe highlighting
hair and casting shadows

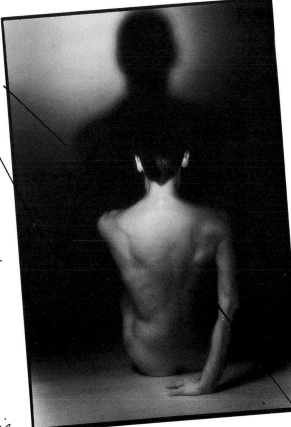

Model: Martin Snaric

Judith – my wife
4½ months pregnant

Photographed in March 1983
at our Connecticut home

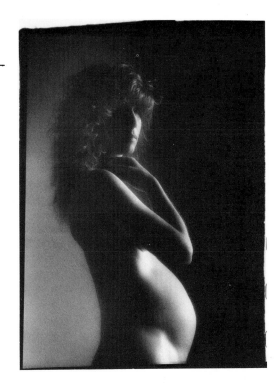

natural light through
window
– reading made by
through-the-lens
metering

Minolta X 700
100 mm lens

Minolta x700
with 50mm lens

1 head at face
casting shadows

1 strobe head
with Balcar
strip light

this highlights body

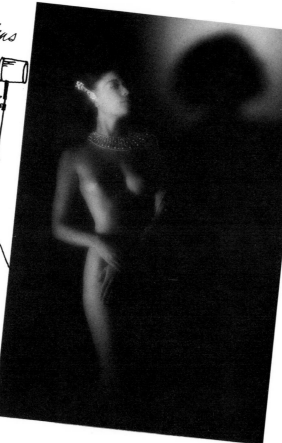

Agfa B/w 400 ASA
pushed 3 stops

Processed with Rodinal
and Printed on Portriga #3
paper (warmer tone)

Hair and makeup:
Jerry Mylnychuk

Camera: Minolta x700
lens: 50mm

film: Agfachrome 200
pushed to 400 ASA

light source: Balcar
monobloc 600 w.s.

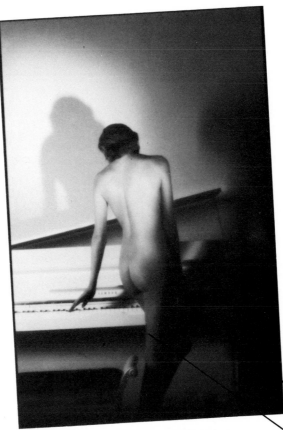

Tried to match the
elegant feel of the white
Piano, with lighting
reminiscent of Hollywood
glamour portraits —

filter: 81A diffusion with
nylon stocking

1 head on strobe direct
from here with grid —
the direct strobe
cast shadows

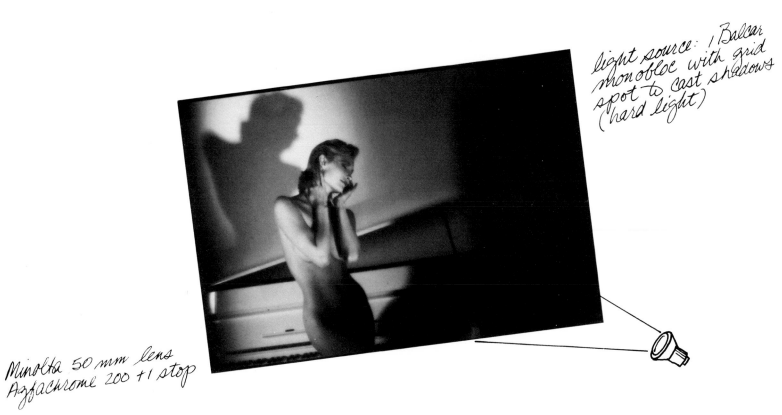

light source: 1 Balcar
monobloc with grid
spot to cast shadows
(hard light)

Minolta 50 mm lens
Agfachrome 200 +1 stop

Minolta zoom at 35 mm
of lens on X700

light ray effect:
petroleum jelly smeared
on skylight filter

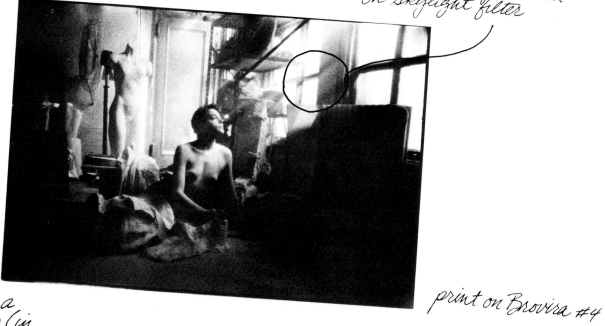

Photographed in a
sculpture studio (in
New York City) under
available light — Again,
the idea of the nude form
as sculpture

recording film rated at
1600 ASA — developed
in Rodinal

print on Brovira #4

Minolta X700
35-105 mm Zoom

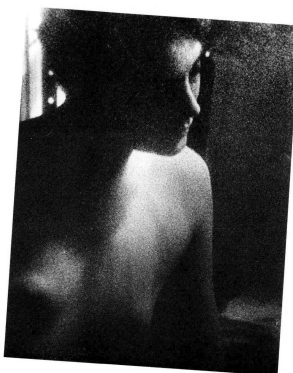

Processed in Rodinal 1:25
for 12 minutes

natural light

Print on Brovira #3 for
cold tone matching
extreme contrast of
recording film

recording film
ASA 1600

light source: Balcar
strobe with 2 heads -
1 head directly at model
casting shadow
1 head on background
with grid spot

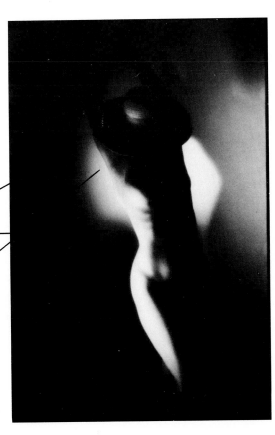

filter 81A

film: Agfachrome 200

camera: Minolta X700
with motor drive
lens: 100mm

pose model to catch light
on inside of left arm -
work with highlights
and shadow to show form

light source: 2 Balcar strobes

black seamless paper
for background

first head

Catch tension in hand,
and feeling of movement

camera: Minolta X 700

lens: 100 mm
film: Agfachrome 200

second head

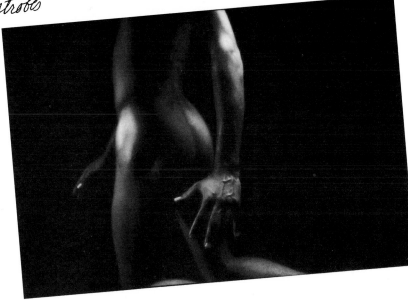

Model: Phillip Priolean

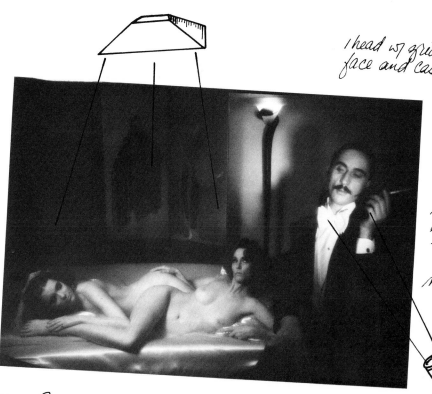

use B&W infrared
... print Portriga #3

1 head w/ grid to highlight
face and cast shadows

my assistant, Victor
as decadent man
- use Phillip Priolean
to style
models: Victoria Hale
and Bobbi Burns

Jean Jacques Beame Gallery
712 Madison (after
Steinway shoot)

unusual deco pieces
with Erté screen
(getting from Ron Parker)

Jim Brusock: hair & makeup
(trim Victor's moustache)

use Allan to assist

Agfachrome 100 -
daylight film lit by
tungsten light for a
warmer tone

try to capture feeling of
hot summer day -
perhaps near a pool
or beach

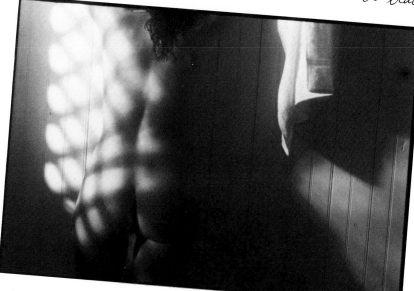

light source behind
latticework in window
of set.

Minolta XK motor -
50 mm lens

leave set from Saks shoot.
Strike set 9/20

shoot Jan. 16th

natural light - 11 AM
front studio floor

slight diffusion

Agfachrome 200
pushed 1 stop

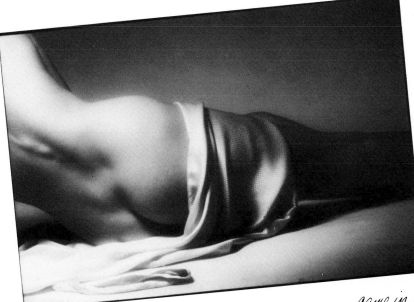

Minolta 35-105mm zoom

came in closer to capture
form of body and flow of
fabric and make them
work with each other

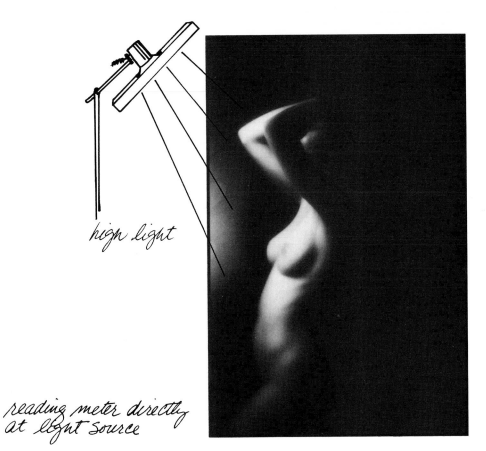

high light

reading meter directly at light source

Model: Christina Engelhard

Camera: Minolta xk motor
lens: 100mm

crumpled paper used for backdrop

light from side emphasizes texture of backdrop, as well as lines of model's back

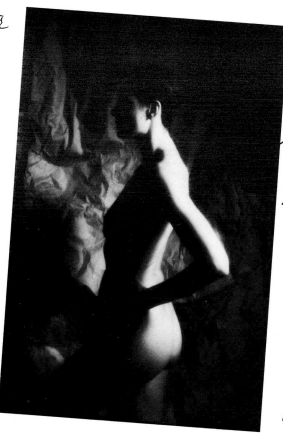

exposure made with Minolta III meter in direction of light – thus the dramatic shadow on the side of the model's face.
Model: Dawn Young

Balcar strip light to this area – also hits background

film: Agfachrome 200
filter: 81A

Contrast fair skin of woman
with dark skin of man

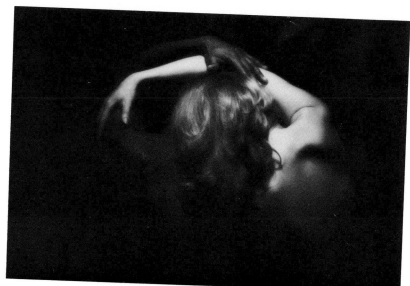

simple lighting: bounce
1 head with soft box

Capture the feeling of a
woman "flowing" around
the strong support of
a man.

Jill DeVries (from Chicago)
& Phillip Prialeau, models
TUES. at studio 6:PM

pose model to form curving,
sensuous diagonal
across diagonal frame

light source: 1 Balcar
Rapid 600 with LB 61
soft light box w/ grid

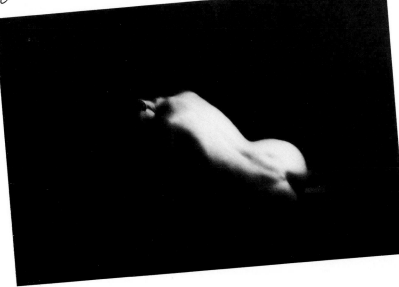

use XK motor
and zoom –

shooting on black seamless
in studio

film: Agfachrome 200
pushed 1 stop to 400 ASA

Camera: Minolta X700

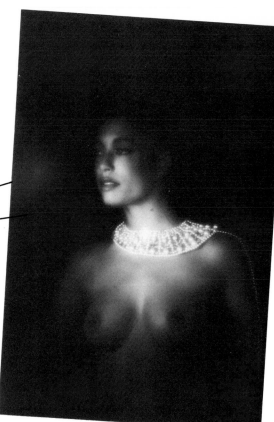

2nd head with spot grid
directly toward face

light source: Balcar strobe
2 heads

1 head w/ strip light

81A diffusion filter
(skylight with hairspray)
helps necklace glow
against warm skin

diffusion achieved with
hairspray on skylight filter

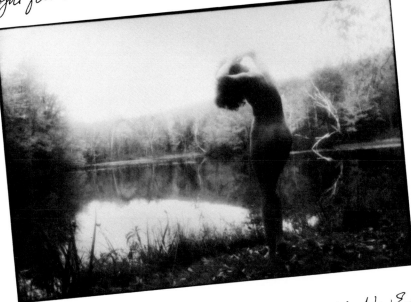

sometimes the arc
of a body can evoke
feelings that a facial
expression can't.

35 mm lens

Photographed in New England -
Stockbridge, Mass, October

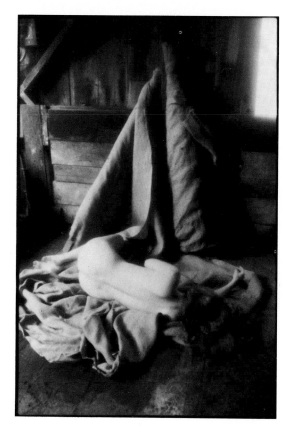

contrast rough texture of barn with milky smoothness of model's skin

Soft, natural light from open doors

Early Spring in a Southampton barn

Model: Niki Winders

film: Agfachrome 200 pushed 1 stop to 400 ASA

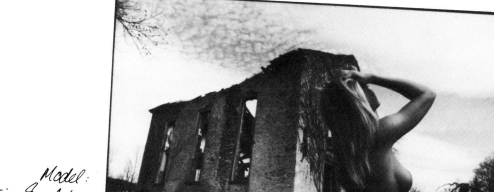

Camera: Minolta X700
lens: Minolta 24-50 mm

Model: Christina Englehard

ruins of old church in southern New Jersey — near Clinton
Nov. 18, 1982

use low camera angle to include dramatic sky and model responding to sky

photographed at 24 mm focal length

Camera: Minolta X700

lens: 35mm f/8
film: Agfachrome 100

contrasting hard, jutting
angles of rocks with
smooth, sensuous lines
of model

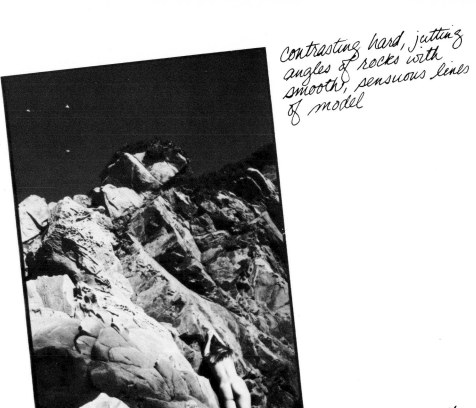

polarized sky

natural light

Photographed on the
California coast

Photo taken in woods
2hrs from New York near
New Jersey / Penna. border

An air of mystery and
fantasy - why is the
nude on these steps -
where do these steps lead?

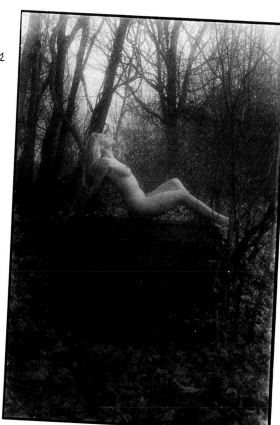

Printed on Agfa Portriga #4
for warm tone and more
contrast to bring out grain

film: Agfa pan 400
Pushed to 600

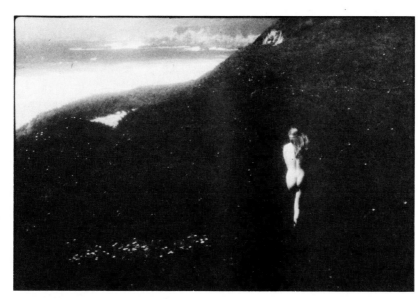

film: Agfachrome 100

California coast
in background

Camera: Minolta x 700
with motor
lens: 100 mm

Position model to balance
frame - form counterweight
to open sea in left corner.

The hat adds an air
of mystery - and ambiguity

use Minolta III meter
incident reading, direct
to light (keep shadow
dark)

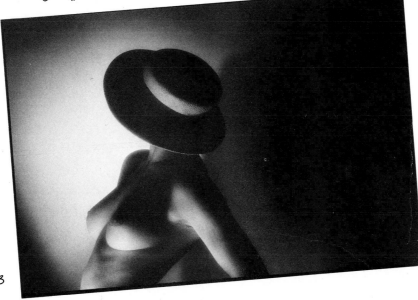

use strobe, spot,
direct light (hard)
w/ grid (keep beam
narrow)

Print on Portriga #3
for warm blacks

lens: Minolta Zoom
35-105 mm

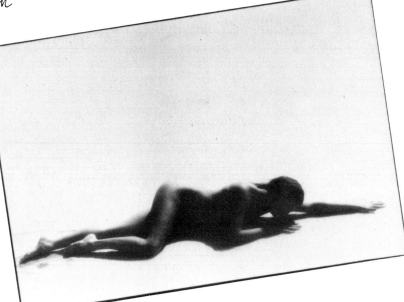

Camera: Minolta X700
w/ motor

film: Agfachrome 200
pushed 1 stop

Photographed on a
Long Island beach
on a cold, sunny
winter day -
but the mood is
that of a drowsy
summer afternoon -
of sleeping open to the warmth
of the sun and sand.

105 mm focal length on
Minolta 35-105 mm zoom.

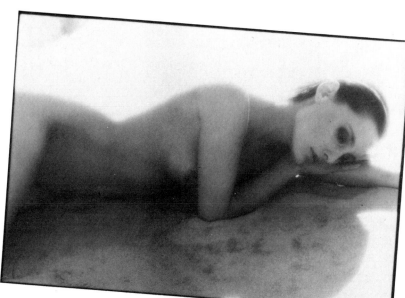

Push 200 ASA film 1 stop
to 400 ASA
Warm up with 81A filter

Model: Kriss Ziemer

film: Agfachrome 100
pushed 1 stop

photo taken at a
Japanese inn –
Nara, Japan

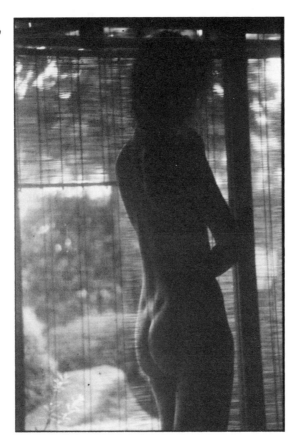

natural light:
highlighting side of model

through-the-lens metering
in direction of windows

Camera: Minolta x 700
lens: Minolta zoom 35-105 mm

Shadow from window pane
adds graphic oblique line –
increasing the feeling of
movement and tension

window light

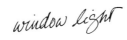

morning light

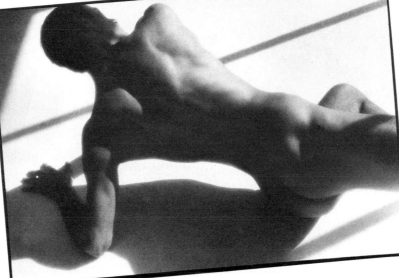

develop in Rodinal

Agfa 400 B&W
pushed 1600 ASA

Model: Martin Snaric

on white floor of studio

direct sunlight

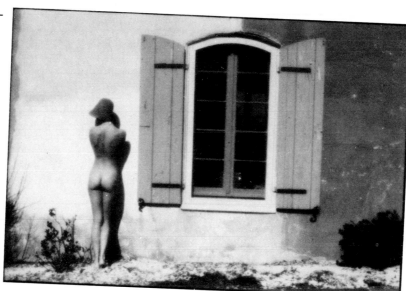

Camera: Minolta x 700
with 100 mm lens

Agfachrome 200 film

81 A filter

contrast bright red spot of
hat with larger blue area
of shutters

light source: strobe w/
1 head 45° to right side
of model

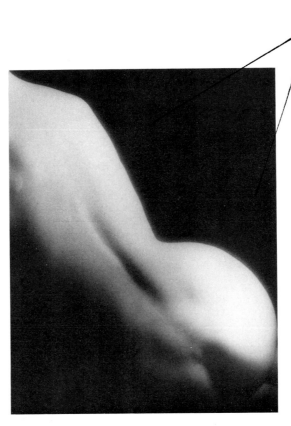

Camera: Minolta x 700
with 100 mm lens

film: Agfa B/w ASA 100
developed in Rodinal &
printed on Brovira #3

Minolta X700 w/ motor
and 50 mm lens

spot strobe
casting shadows

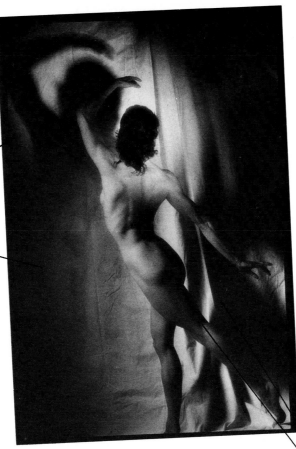

Print with ragged
borders to compliment
textured background.

Photograph of Lisa Lyons
at my studio using
painters dropcloth
as background

infra red B/W film rated at
400 ASA – printed on Agfa
Portriga #3 paper

Balcar LB61
soft fill strobe

direct sunlight

Agfachrome 200 ASA
diffusion & 81A filters

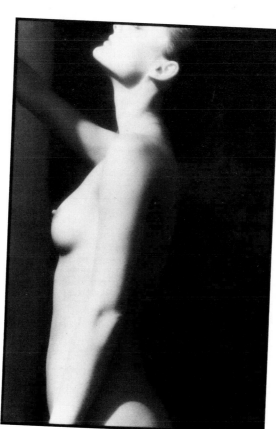

Minolta X700

form of body and face
combined – without
showing the whole
of either

Camera: Minolta X 700

lens 35-105 mm
Minolta Zoom.

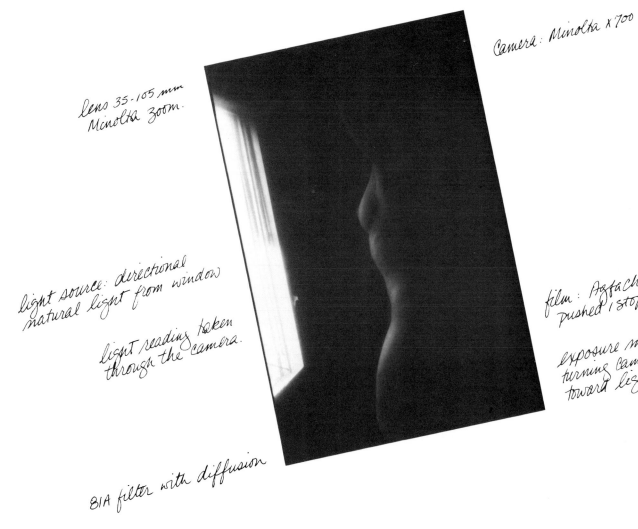

light source: directional
natural light from window

light reading taken
through the camera.

film: Agfachrome 200
pushed 1 stop

exposure made by
turning camera directly
toward light source

81A filter with diffusion

exposure reading taken
off woman's skin

camera tilted in order to
achieve dynamic diagonal
line

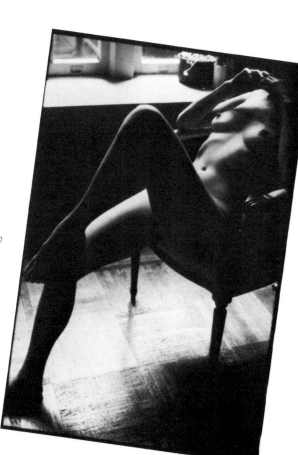

natural light from
window cross-lighting
model

available sunlight
in middle of day

X 700 Minolta

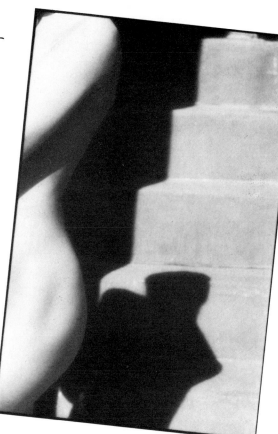

contrast. curves of human
body with geometric
lines of steps

81A filter –
Agfachrome

natural light from
window with
northern exposure

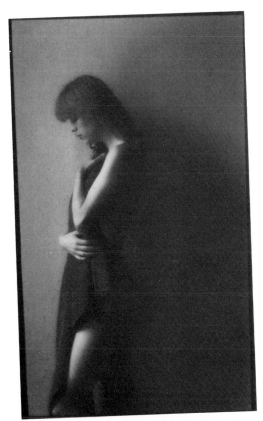

100 mm Minolta lens
film: 200 ASA Agfachrome

Model: Unni

camera: Minolta x 700 w/ motor
lens: 50mm

filter: 81A
and slight diffusion

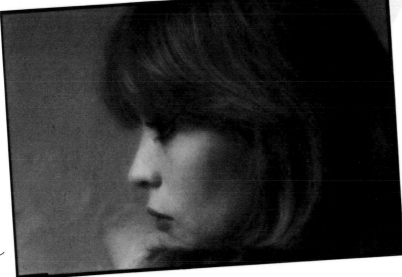

light source:
natural light from
window with northern
exposure

meter reading (through the camera)
in direction between model and
window to maintain highlights

light source:
CB 61 lightbox
w/ grid

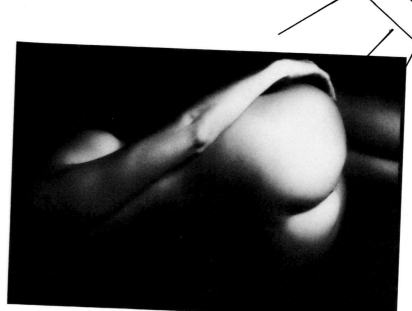

camera: Minolta x700
100 mm lens

Agfachrome 200 81A filter

light source: Balcar 600 w.s.
strobe with one head

light source: floor
lamp with normal
household bulb

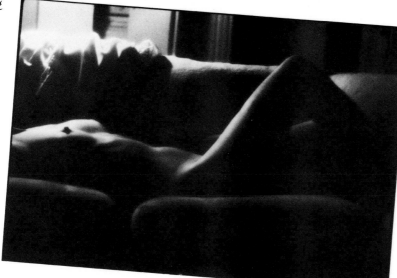

Camera: Minolta x700
w/ motordrive
50mm lens -

Agfachrome 200
pushed 1 stop

daylight film with
this light source
gives the warm tone

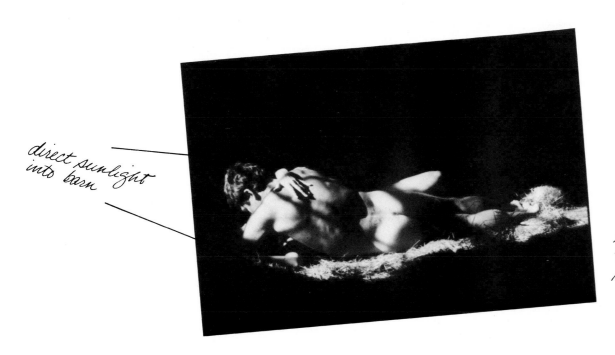

direct sunlight
into barn

exposure reading taken
through the lens with
meter reading sunlit
area.

Minolta 35-105 mm Zoom

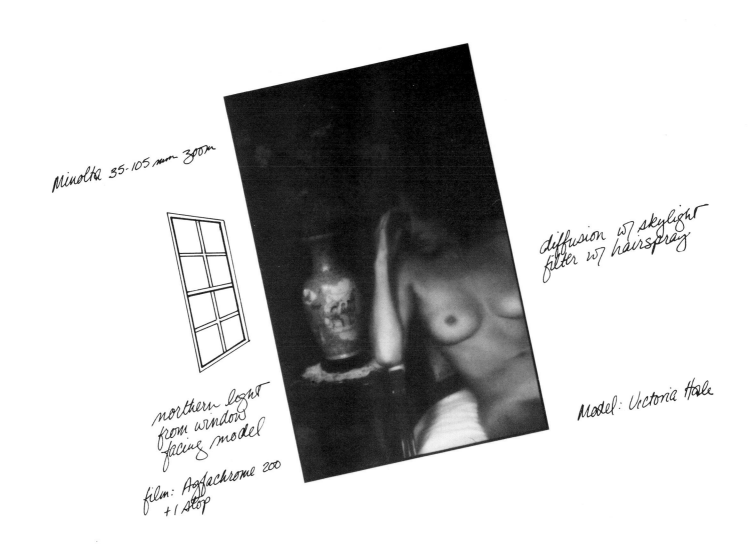

diffusion w/ skylight
filter w/ hairspray

northern light
from window
facing model

film: Agfachrome 200
+ 1 stop

Model: Victoria Hale

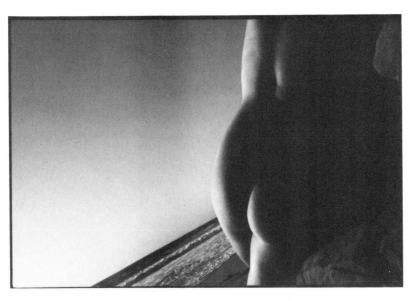

tilted camera for
dynamic tension
produced by
diagonal horizon

Photographed late in the
day for warm tone

black seamless
paper for
background
to provide an
air of mystery

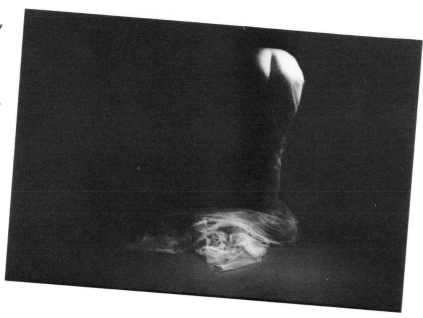

shot in studio with
one strobe head above
model

Seems to work best as horizontal,
though subject is really vertical

camera: Minolta XK motor
lens: 100 mm

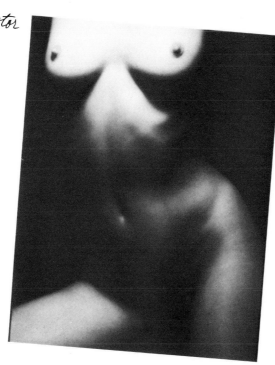

light source:
Balcar Rapid 600 w.s.
fitted w/ LB61
lightbox w/ grid

light reading made w/
Minolta III strobe meter
in direction of light —
thus this area darkens

Agfachrome 200
+ 1 stop

slight diffusion
81A filter

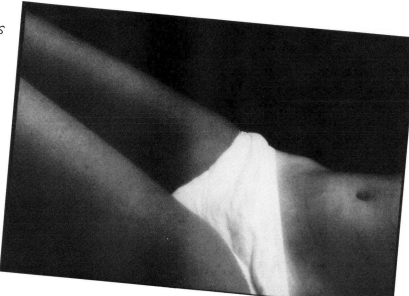

camera: Minolta x 700
lens: 100 mm

photographed in
natural light

slight diffusion with hairspray
on skylight filter caused glow
from highlights

light source:
natural light
from window

camera: Minolta x700
lens: Minolta zoom
 35-105 mm

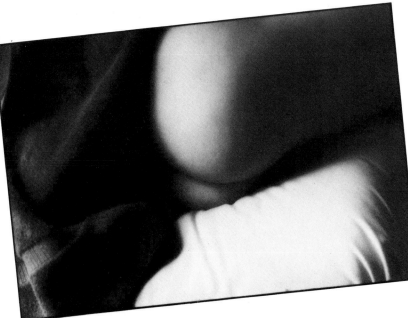

film:
Agfachrome 200
pushed to 400 ASA

filter: 81A + diffusion
(skylight filter with
hairspray)

spot casts shadow
of seltzer bottle

Minolta x 700
with 35-105 mm zoom

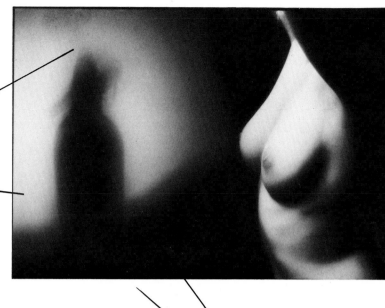

Agfachrome 200
+ 1 stop

Balcar LB61
box with grid

light source:
natural

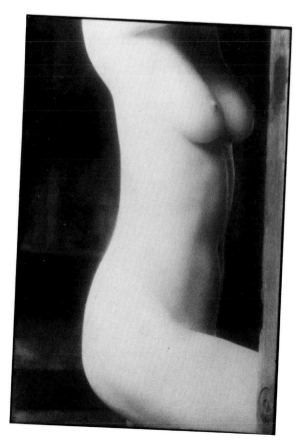

Camera: Minolta x 700
lens: 100 mm

diffusion filter

film: Agfachrome 64

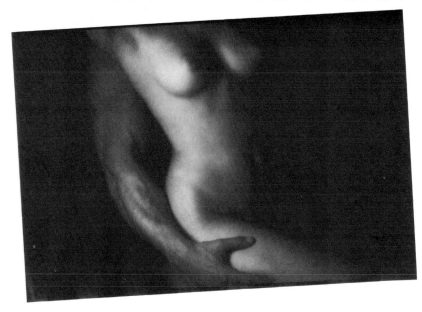

shooting from Video -
"Famous Photographers"
series
produced by Sherwood
Video, Chicago

models:
Joe De Silva
& Mary McCoy

warm, red-yellow tone a result
of using incandescent lights with
daylight film

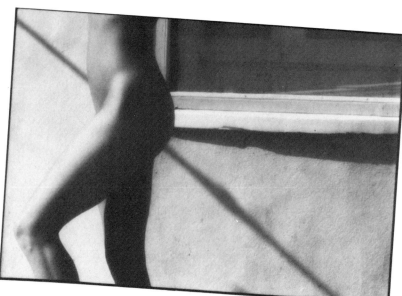

direct sunlight
working with existing
shadows & forms

slight diffusion
hairspray on skylight
filter + 81 A

Agfachrome 200
+ 1 stop

Agfa 100
50 mm lens

lit by electronic
strobe in studio

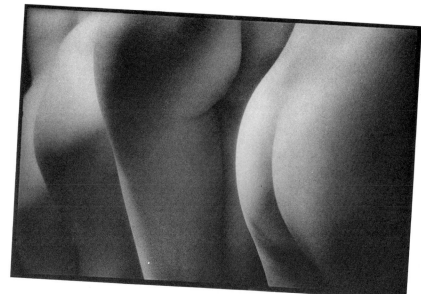

Print on #3
Brovira paper
for cold tone

4 nudes
B&W

natural light

Minolta x700
lens: Minolta zoom
35-105 mm

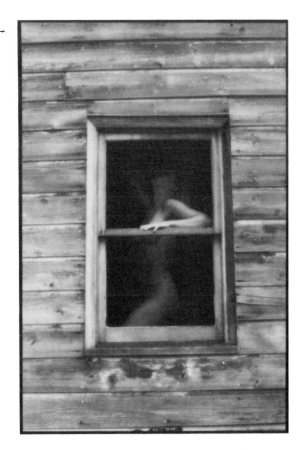

81A filter w/ diffusion

Agfachrome 200
pushed to 400 ASA

Minolta X700
w/ 50 mm lens

soft light
(1 light only)

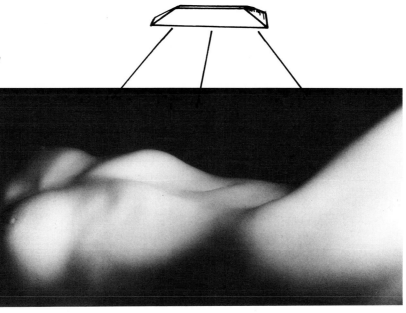

black seamless

B&W Agfa 100

cropped to emphasize long
lean lines of model's torso

available light

like similarity
of curves

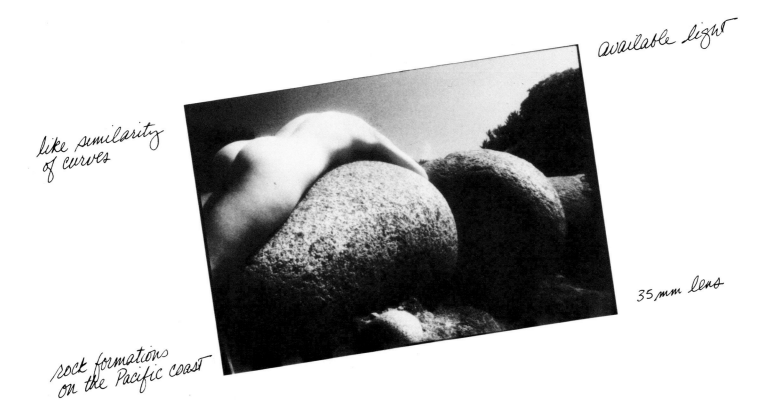

35 mm lens

rock formations
on the Pacific coast

recording film
1600 ASA for strong
grain and high
contrast

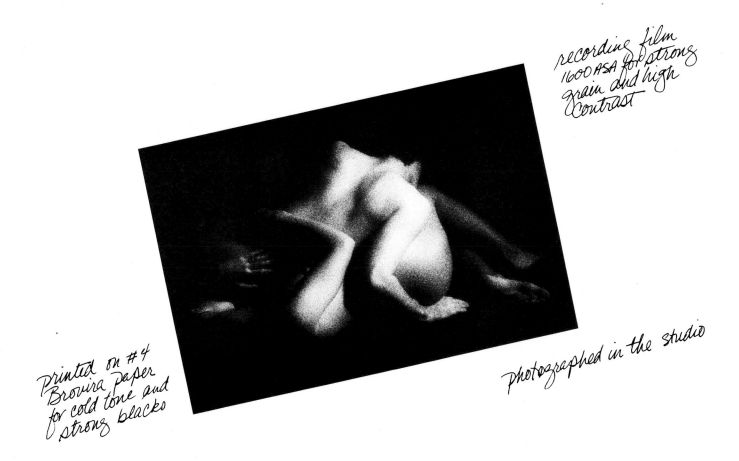

Printed on #4
Brovira paper
for cold tone and
strong blacks

photographed in the studio

lit by one Balcar
soft box and strobe
above models

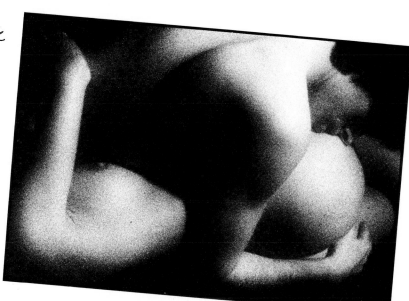

closer cropping
(in camera)
further abstracts
image

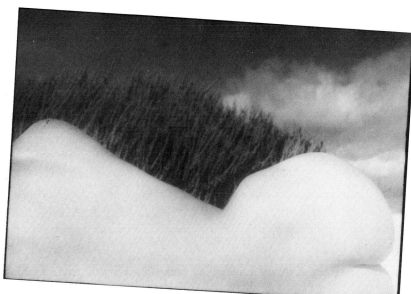

photographed in the
Canary Islands
off coast of North Africa

woman's hand adds
contrast to curve of
her hip and provides
focal point for image

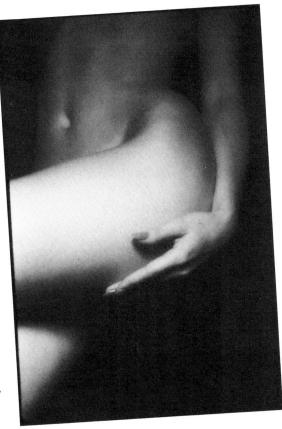

photographed in
the studio with
a Minolta x700
camera and
100mm lens

shooting done
for poster

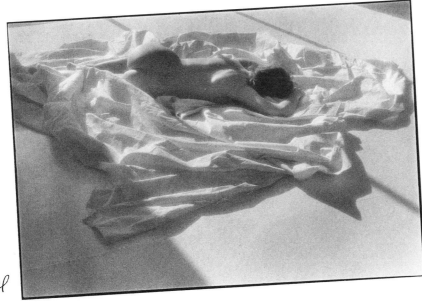

B&W Agfa 100.
+3 stops
process in Rodinal

35 mm Minolta lens

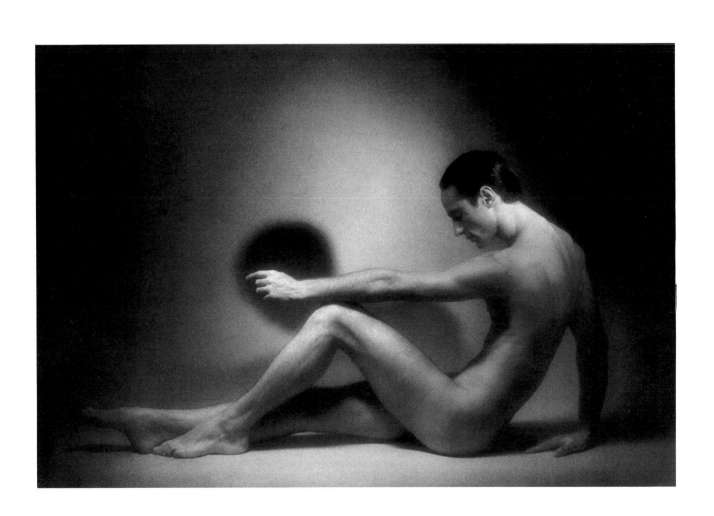

Acknowledgments

Rocco Noto Sculpture Studio
Jean Jacques Beame Gallery
Phillip Prioleau
Jim Brusock
Jill De Vries
Ron Parker
Erte
Lisa Lyon
Christine Vincent
Joyce Bartle
Dawn Young
Kerry Harper
Judith Farber
Denise Coward
Kriss Ziemer

Christina Engelhard
Susannah Bianchi
Unni
Martin Snaric
Mary McCoy
Victoria Hale
Joe Silva
Gwendolyn
Lorraine Altomuta
Susan Gentry
Rick Sammon
Lee Farber
Charlotte Farber
Jekno
New York Film Works
Harold Ceuter

Janet Rogler
Alan Zackary
Victor Podesser
Carol Barnstead
Allen Bragdon
Jean Chitty
Connie Clausen
Michael O'Connor
Virginia Podesser
Brian D. Mercer
Guy Kettelhack
Jim De Merlier
Niki Winders
Barbara Swab
Jerry Mylrychuk

Edited by Michael O'Connor and Marisa Bulzone
Designed by Brian D. Mercer
Graphic Production by Ellen Greene